AS WE SEE IT

THE COLLECTION OF GAIL AND ERNST VON METZSCH

FOREWORD BY MIN JUNG KIM

OBSERVATIONS BY ERNST AND GAIL VON METZSCH

ESSAY BY KATHERINE FRENCH

EDITED BY ARTHUR DION

M

NEW BRITAIN MUSEUM OF AMERICAN ART

Published on the occasion of the exhibition

AS WE SEE IT

THE COLLECTION OF GAIL AND ERNST VON METZSCH

October 21, 2016 - January 8, 2017

M

New Britain Museum of American Art

56 Lexington Street
New Britain, Connecticut 06052
Telephone 860.229.0257
Fax 860.229.3445
www.nbmaa.org

First Edition

Design
Vincent-louis Apruzzese
Behemoth media

Reproductions

© Eric Aho, © Ben Aronson, © Joseph Barbieri, © Gerry Bergstein,
© estate of Bernard Chaet, © Robert Ferrandini, © Steve Hawley,
© Linda Holt, © Sedrick Huckaby, © estate of Jon Imber, © Andy Karnes,
© Catherine Kehoe, © Joseph McNamara, © Janet Monafo, © George Nick,
© Thomas Paquette, © Scott Prior, © Alston Purvis, © Paul Rahilly,
© Richard Raiselis, © Harold Reddicliffe, © estate of Richard Sheehan,
© Ed Stitt, © estate of Sarah Supplee, © Suzanne Vincent,
© Julia von Metzsch Ramos, © John Walker, © Jeff Weaver,
© estate of Lucette White, © Ernst von Metzsch

Photography by Bill Kipp
except pages 29, 42, 56, 57, 74, 83, 86, 105, 132 ,144, 145, 146, 170 by A.P.Alexander
67, 162 by Steve Hawley; 90, 91 by Bill Orcut; 149 by Dana Salvo

Library of Congress Control Number: 2016945934

Printed and bound by J.S. McCarthy
Augusta, Maine
in an edition of 2000 copies

Distributed by
University Press of New England

CONTENTS

ACKNOWLEDGMENTS

Gail and I would like to thank Min Jung Kim, the director of the New Britain Museum of American Art, for giving us the opportunity to show our art collection in such attractive spaces. Many thanks also to Lisa Williams, Stacy Cerullo, Keith Gervase, Linda Mare, Melissa Nardiello, and Bradley Olson of the museum who all played important roles in making the exhibition happen and to Vincent-louis Apruzzese for his fine design of this book.

From our side, this exhibit would never have come to fruition without the expertise shown by Arthur Dion and Meg White of the Gallery NAGA in Boston. Arthur reviewed the essays, made sure they were completed in a timely manner, and made quite a number of editorial improvements without taking away the spirit in which they were written. Meg managed the inventory of paintings to be shown, an inventory that kept changing as Gail and I exercised our somewhat inexperienced curatorial prerogatives, complicating her work. Arthur, with Meg and Andrea Dabrila, also managed the production of this catalog. We are fortunate that Katherine French, of Catamount Arts in Vermont, was willing to write the essay for the catalog. Katherine knows the Boston art scene and its history quite well and is familiar with the work of many of the artists and with our involvement as collectors. Along with Arthur and Meg, Amnon Goldman of the Mercury Gallery in Rockport, Massachusetts and Joanna and Alan Fink of the Alpha Gallery in Boston play an important role in how we look at art and how our collection has come together. We want to thank Susan Paine, who, like her late husband Steve, is such a role model when it comes to collecting.

Gail and I know most of the artists represented, but we did not involve them in the process of selecting the paintings to be shown. They may be wondering what we had in mind with the inclusion of certain works and with our discussion of them. Not all that much that one can express all that easily, we would say. The creation of art and the appreciation of it are highly personal and not a great subject for a lot of verbiage, other than the anecdotal, such as the description of painters' techniques. The artists we know are quite interesting people who have enriched our lives, and that's the only acknowledgment we think is needed here.

The undertaking of this production therefore was a real pleasure, as from the start the participants were familiar with the players and had the generosity of spirit to deal with our foibles.

Ernst and Gail

FOREWORD

MIN JUNG KIM
Director, New Britain Museum
of American Art

It is with great pleasure that the New Britain Museum of American Art presents the exhibition *As We See It: The Collection of Gail and Ernst von Metzsch*. This exceptional gathering of work is a testament to the artists', and, more significantly, the collectors' unique perspectives on art, observation, and life, revealed precisely "as they see it." In his insightful essay included in this catalog, Ernst invokes a quote by Edward Hopper: "Great Art is the outward expression of an inner life in the artist, and this inner life will result in his personal vision of the world." The same can be said of Gail and Ernst's collection as a reflection of their own personal vision - one that has become deeply enriched by their 30 years of patronage.

During the early phases of developing their collection, Gail and Ernst began with acquiring urban scenes and then expanded to seascapes and more broadly to paintings by Boston and New England artists whose work greatly interested them. Today, their collection reflects a multitude of styles and subjects that might best be described as "contemporary realism" and includes naturalistic landscapes, still lifes, portraits, and interiors, as well as colorful, evocative abstractions. Most remarkably, the works attest to Gail and Ernst's enduring commitment to supporting the careers of New England-based artists. As longtime residents of Massachusetts, they have been drawn consistently to regional artists, such as Ben Aronson, Bernard Chaet, Steve Hawley, George Nick, and Paul Rahilly, among others, whose work reflects the daily lives, experiences, and environments the artists and collectors share.

Rather than collecting encyclopedically, Gail and Ernst have acquired the work of select artists in depth, a practice that reflects their dedication to nurturing and developing personal relationships with artists. They have been consistent with their encouragement and support throughout artists' oeuvres, but perhaps most importantly at crucial moments in artists' careers. Invested and interested in artists, their lives, and the worlds around them, as well as the technical issues and processes that inform their work, Gail and Ernst have amassed their collection through active and ongoing conversations with artists and also with curators, dealers, and fellow collectors whom they admire and with whom they share a dialogue. We at the New Britain Museum of American Art are enormously grateful for the opportunity to establish our own meaningful collaboration with Gail and Ernst through the organization and production of this exhibition and catalog.

I am most thankful to Gail and Ernst for generously agreeing to loan their collection and for their tremendous dedication to this extensive exhibition and publication. We are thrilled to include their insights within this catalog, together with an illuminating text by Katherine French, to whom we are most appreciative. We extend our sincere thanks to Arthur Dion, Meg White, and the entire staff of Gallery NAGA in Boston. I am indebted to former director, Douglas Hyland, for initiating this exhibition with the help of Emily Misencik, former assistant curator of the New

Britain Museum of American Art. I would also like to express my gratitude to the following staff members who contributed to this undertaking: Lisa Williams, Stacy Cerullo, Keith Gervase, Bradley Olson, Claudia Thesing, Amanda Shuman, Melissa Nardiello, Nick Artymiak, Thomas Bell, Georgia Porteous, Melanie Carr, Linda Mare, Heather Whitehouse, Katy Matsuzaki, Catherine Clark, Ashley Zimmer, and Tom Gruber.

EDITOR'S NOTE

At Ernst and Gail's request, one view, from fairly close range, of the collectors and their collecting.

Realism?

Perhaps realism visited by a force from another dimension.

There are plenty of skilled and even intriguing painters who work under the gargantuan tent of realism who are not particularly compelling to Ernst and Gail.

Their interest has to do with what's done with the mimetic skill, the purposes to which it's put – point of view, ambitions beyond description, what's being communicated about the qualities of being human in this world.

(There's also the materiality of paint, which is a source of inexplicable fascination for them and, really, for all of us who work with paintings.)

To cite only a few examples:

John Stomberg, now director of Dartmouth's Hood Museum, coined the term existential realism to describe the work of George Nick, and that term does a nice job of expressing George's documentation of his encounters with his subjects, his goal of recording his experience of phenomena. It's quite psychological to my way of thinking. George would counter that it's perceptual, but he would acknowledge that our recognition of our perceptions is directed by our habits of mind.

I'd say that Ernst and Gail love the vivacity of George's encounters and his determination to accurately communicate the terms of his visual epiphanies.

In Richard Raiselis's work I believe they love the rare combination of orderliness and wonder, which one sees also in Sarah Supplee.

In Joseph McNamara, the stunning complexity of his visual perception, the powerful suggestion that we're using but a fraction of our ability to see, that we're radically simplifying the visual world as a strategy for making our way through it, a contention with which, incidentally, George Nick would agree.

In Paul Rahilly, the absurd and glorious connections and overlaps between objects and figures in our visual field.

In Steve Hawley and Ed Stitt and Richard Sheehan and Scott Prior, the radiance and splendor glowing out from everything that's in front of us.

In Eric Aho and Ben Aronson, deft tribute to that splendor, viewed simultaneously closely and from afar.

In Julia von Metzsch Ramos, the conjuring of the energies enlivening space.

In Robert Ferrandini and Bernard Chaet, the aura of magic.

All of these painters are making assertions about our underutilized humanness.

"What's the animating spirit here?" That's the question Ernst and Gail effectively ask as they look at art.

Arthur Dion is director emeritus of Gallery NAGA and business partner of his successor, Meg White.

WHAT THE COLLECTION MEANS TO US

ERNST VON METZSCH

Gail and I appreciated Douglas Hyland's suggestion that we exhibit our collection of paintings at the New Britain Museum of American Art. We met Douglas, then the museum's director, in 2014 on a trip to Singapore and Indonesia organized by his wife Tita. During a subsequent visit to our house in Manchester, Massachusetts, he offered the idea.

Gail and I enjoy our collection quite a bit, but while we like to show visitors around, we would never have come up with the idea to publicly show the paintings. We accepted Douglas's offer, and it led to a lot of thinking on our part about what the collection means to us, to what extent there is organization and focus in the way we collected it, and why we collected the works.

Earlier this year we had the pleasure of meeting Min Jung Kim, the museum's new director, and we have very much enjoyed bringing the exhibit into being with her.

Most of the collection is representational art produced in New England. My mother liked to paint, but was too busy working and taking care of her children to do much until her later years. I make three or four paintings per year, and our daughter Julia is a professional painter. This probably has led to a great appreciation of artists who can draw and who can handle paint in an idiosyncratic way. One might think of painting as a pleasant undertaking, done in a shady spot with a beautiful view. Drawing is difficult, and painting in a manner that interprets what we see in an interesting way is, as I have learned from my own attempts, even more difficult. Making representational work (as well as good abstract painting, about which I know less) is a hard and lonely undertaking, with little support, requiring a lot of thinking and practice and recovery from setbacks.

The viewer's role is to relate to the artist's way of doing things, and if he or she can't, there is no need for explanations. There is a tendency by observers to ridicule art that is not understandable or hokey to them, but that should be irrelevant to the viewer who enjoys it.

We did not put this collection together in isolation, and Gail and I spend a fair amount of time talking about art, visiting exhibits, and reading about it. We enjoy discussions with artists, dealers, and curators at museums, but we don't follow anyone's guidance on what to collect. At the risk of sounding sentimental, the paintings we own are like friends and are part of our sense of our past and ourselves. Many paintings are associated with a period in our life together and bring up old memories. We take a dim view of the idea that we should have actively traded paintings to "upgrade" our collection as our means to buy art improved. If at some point we enjoy a painting less, it will be stacked against the wall, and maybe we'll take to it again later.

We own some European art, but most of our collection, and all the art shown here, is American and local. The Dutch paintings we own have for me a nostalgic element. The atmosphere in northern Europe is much more subdued and

pastel than that of New England, and we are drawn to the color and value schemes used by American Impressionists and painters of the Ashcan school. We are attracted to local art; it encourages one to meet the artists, and it makes one think about the two-dimensional interpretation of what's around one all day. These observations, however, are not meant to imply that, in my mind, New England is more beautiful than the Netherlands.

I started collecting before I met Gail, around 1980. I would like to single out Stephen D. Paine (1932-1997) as an inspiration for collecting. I met Steve at Wellington Management when I joined the firm in the early 1970s. He was one of the founders of a Boston investment firm which merged with Wellington Management Company in the late 60s. Steve contracted polio when still in his twenties, and during a long recuperation, which left him confined to a wheelchair for the remainder of his life, he spent a lot of time thinking about art. He was a trustee at the Museum of Fine Arts in Boston and in charge of putting Wellington's art collection together. Although the firm did not always have much money to add to the collection, he was always on the lookout.

I think he was the best and most interesting collector in Boston in the second half of the 1900s. Steve essentially followed his own taste, with his wife Susan the only significant influence, and collected all kinds of art, mostly in Boston, California, and New York. In the process Steve and Susan discovered good early work by some painters who later became well-known and also by lesser-known artists. Steve did not talk all that much about the art, but when I was struck by some painting in the office he would tell me which gallery it came from and suggest I take a look for myself. If you asked him what he thought of a painter, he would say "OK," "pretty good" or "not much" or sometimes a longer one-liner, like "Rahilly paints whites really well."

Steve was not being reticent; better than anyone else he understood that there is often not much to say about a painting that speaks for itself. You like it or you don't, and you don't have to explain or advertise why. Some collectors can be quite loquacious about why they like things, but that does not necessarily mean they have better taste or that the artwork is any better. The less understandable art becomes, the more there is a likelihood of the work being described in superlative terms such as "incredible" or "stupendous," "mind-blowing," etc. Such adjectives are considered unnecessary when reviewing recognized old masters and often reflect the insecurity of the speaker that he or she may be totally out to lunch when pontificating on the merits of a particular piece of work. I can't describe any of our paintings as stupendous.

At Wellington, beginning in the 1970s, I got exposed to a number of American artists, such as George Nick, Richard Sheehan, Scott Prior, Paul Rahilly, Janet Monafo, Ed Stitt, Bernard Chaet, Gerry Bergstein, Gregory Gillespie, Neil Welliver, Suzanne Vincent, and Anne Neely from New England and Richard Estes, Sarah Supplee, William Beckman, and Jane Freilicher from New York. Steve collected a wide variety of work, much of which I don't remember too well (mostly as a result of what must be age-related memory loss) until I see them in one of my sporadic visits to Wellington's offices. This at times leads to a pleasant surprise, when I see a painting I liked and have not seen in many years. A number of the painters listed above are in our collection and became good friends, which has been very gratifying.

The first American artist who drew my attention before I met Gail was Richard Sheehan, who came out of the Massachusetts College of Art in 1975. Steve had acquired a painting by Sheehan of a three-decker in a Boston neighborhood. I spent a lot of time looking at this painting, as it was in a room where all investment people congregated every morning. (By the way, one of the best habits

I acquired over time, when entering a room, is to always look for a seat with a good view of the most interesting painting on the wall.) Steve told me to visit the gallery on Newbury Street which carried Sheehan's work, with the observation that his paintings were very reasonable, as he was just starting out. Steve was always very value oriented, which I have tried to emulate with sporadic success.

In the 1980s Gail and I got married, had two children, Julia and George, and were generally too preoccupied to collect. We would occasionally visit a museum, but there was too much going on to be actively involved in art together. I bought a George Nick in 1986, *Red Building in Autumn* (1983). Late in the 1980s I bought Scott Prior's *Yellow Chair* (1988). Wellington has, in my mind, the most important Scott Prior, *Bedroom in Winter* (1979). Our Prior, which we got by a stroke of luck when a collector returned it to the gallery, gets close. Gail did not mind having these paintings and the earlier work of Sheehan in the house and actually liked them. I believe, however, that it was not until the 1990s that we realized how visually oriented we both are and that our tastes run very much in the same direction. Maybe the intermezzo of the 1980s was required for us to recognize our common interest; maybe we could have discovered it earlier. Gail and I are lucky in many respects, and life with a spouse with different taste would be challenging for both of us, I think.

Gail and I started visiting blockbuster shows at museums. The two van Gogh exhibits at the Metropolitan in New York stick out in my memory, and Pissarro and Monet in Boston. Blockbusters can attract so many people, but are great in pulling together much of an artist's work. (A good way to enjoy busy exhibitions is to skip looking at the paintings which are part of the audio tour.) Visiting these shows, one thinks of great artists obsessed by a goal and formulating an idiosyncratic and interesting way of communicating what they

see. In my own endeavors, I also get obsessed while painting, which is one of the great merits of this kind of activity. Fortunately for my dealer friends, I don't try to push on them the idea that occasional bursts of obsession lead to the creation of masterpieces.

Talking about museums, Gail and I are trustees of two different museums in the Boston area, the Peabody Essex Museum in Salem and the Museum of Fine Arts in Boston, respectively. Museums are very successful in competing with other institutions such as symphonies and sports franchises and are proof of the fact that many people find pleasure in having an interesting visual experience. Museums are also evolving in many ways, several having to do with attracting the interest of a wider and younger group of visitors. This is wonderful, as viewing art is a great thing. Both Gail and I feel that our life's experience would have been richer if we had spent more time with art when young. We find that one of the few positives of getting older is that one acquires the wisdom to appreciate art more.

Private collecting has one leg up on the museums. Paintings are produced to hang in a place so that you can savor them over a long period of time and look at them as often as you wish. Museums can't provide long-term access, but the high quality of today's copying technology goes quite a way in alleviating this.

In 1990 Gail and I acquired a small painting by Paul Rahilly. We had two of his paintings at Wellington, about one of which more later in the catalog. We now own a fair amount of work by Rahilly and his wife Janet Monafo. In 1992, Ed Stitt, whose work I also discovered at Wellington, painted a portrait of my older son Roland for his 21st birthday. This was a great success and started our interest in portraiture. During the 90s we befriended George Nick, when I took several painting classes with him. He is a great painter and teacher and has influenced our growing up

with art in many ways. In this period and after the turn of the century Gail and I started to collect more work of the artists we knew, and also befriended Steve Hawley in Newburyport, Massachusetts, and Eric Aho in Saxtons River, Vermont.

Our daughter Julia went to art school at Boston University in 2003, where we got to know her teachers Hal Reddicliffe and Richard Raiselis; later she went to graduate school there, under the direction of John Walker. Over the years we were drawn to the work of Ben Aronson, also with BU connections, of whom we have a number of paintings. Bernard Chaet, of New Haven, Connecticut, and Rockport, Massachusetts, also became important to us.

We also collect the work of Joseph McNamara, who is based in New York City. Joe's work is quite admired by many viewers. Much of his work is in the hands of two collectors. One is Richard McKenzie, who has hung them in his Seven Bridges Foundation in Greenwich, Connecticut. The other collector is showing some of McNamara's work in this exhibit. Another important artist for us is a close friend, Alston Purvis, who is the only truly abstract artist in our collection and whose work we have collected over the years.

And then there is our daughter Julia. We admire and identify strongly with her work. Julia has all that we look for in an artist, an ability to draw, an interesting idiosyncratic style, and self-direction in what she wants to achieve.

Without any particular design on our part, Gail and I kept buying paintings over the years, which was helped by the fact that my income started to rise in the 1990s and we were able to buy some houses with large wall space. For some unexplainable (and one might say unfortunate) reason Gail and I are attracted to large paintings and like to hang them in a location where they can be seen. This creates a challenge we have been able to meet so far. This can't go on forever, as we are reaching an age where normal people downsize, which we

resist with all the energy we still have.

We had little idea how our collection would look as we were collecting, and we are interested when astute observers like Katherine French see a thread. I'll try to describe it as we see it. Essentially, we like representational work which makes it clear to us that the artist can draw and compose and uses paint in such a way that we can see and appreciate how the painter relates to the physical environment. Do we see and feel empathy with the artist's rendition or interpretation of what he or she sees?

On the one extreme, pure photorealism is not interesting to us if there is no idiosyncrasy. We like the painter's approach when it sets the work apart in a recognizable personal manner. Gail and I also endeavor to see what keeps a painting interesting when the connection with what we see in daily life is gradually lost. This implies that skill becomes more difficult to recognize as the painting appears to lose its relation to the environment as seen by the human eye. We feel we don't take any risk by collecting less representational work, as we like what we own and don't have to explain why to anyone. Virtuosity, however, is more recognizable in representational painting and protects us from the "tedious spectacle of ineptitude," as Robert Hughes puts it in his essay praising John Singer Sargent, one of the most virtuous painters of all time.

Some interesting observations on the creation of art come from Edward Hopper. In the 1950s, when representational painting was under severe attack by the leading thinkers of the contemporary art world, Hopper wrote a statement in the publication *Reality* with this opening line: "Great Art is the outward expression of an inner life in the artist, and this inner life will result in his personal vision of the world." He then goes on, "The inner life of a human being is a vast and varied realm and does not concern itself alone with stimulating arrangements of color, form and design."

Hopper deplored the fact that "I find, in working, the disturbing intrusion of elements not part of my most interested vision, and the inevitable obliteration and replacement of this vision by the work itself as it proceeds. The struggle to prevent this decay is, I think, the common lot of all painters to whom the invention of arbitrary forms has lesser interest."

George Nick told me that he has a vision of what he is going to paint, but knows that inevitably it is going to come out differently. But the painting also may be more interesting, so why view an unintended outcome negatively?

I would add that the observer can't distinguish between the original vision and what's left of it after the actual painting process. There is much speculation about all this in the literature about artists, but one is better off just enjoying what's to be seen and thinking about what it means.

Why own so many paintings by the same artists? It has allowed us to learn more about the artists, to see them express themselves in different situations, and to have an opportunity to get their views of their work and their challenges. It should come as no surprise that artists are the most interesting students of the history of art and what it means for all of us.

We own more than 200 paintings, and the question arises what will happen to them after we no longer can enjoy them. We know our children will like some, and an interested museum may want to get one or two. We did not acquire the art for value, so giving it to good friends, or putting it up for sale through a gallery or auction house, looks like the way it will go. Looking at the results of local auction houses, very good so-called non-branded art is quite inexpensive and can be purchased by buyers who will enjoy it without spending a fortune. We don't like the idea of a collection sticking together in some museum storage area, until it can be safely deaccessioned without offending the heirs of the donors. As to the art produced by myself, I think it is just good enough to make the rounds at flea markets for years to come.

MANY A SUBLIME MOMENT

GAIL VON METZSCH

Growing up I knew nothing about art, as it wasn't in our family's range of experience or knowledge. There was nothing hanging on our walls save for a couple of crucifixes. Although I was born north of Boston and lived there, I never had heard of Boston's Museum of Fine Arts until I was seventeen and visited on a class outing. I'm embarrassed to say that all I remember is that I wore my best dress.

I knew I wanted to attend college and to be the first in my family to do so. I worked as a cashier to save enough for the first semester of a community college. Of course I became a liberal arts major.

I studied music appreciation and art appreciation, and they opened up a new world to me. Art appreciation was a general survey with a few photographs. The artists who caught my attention were Braque and Picasso. Paintings by others were beautiful, but seemed ordinary by comparison. I was intrigued by their geometry, by the way Picasso's shapes in space expressed the presence of animals and people, passion and a range of emotions, by the balance and harmony of Braque's compositions. I found the tone-on-tone work in his paintings and collages soothing and his brightly colored landscapes invigorating.

Soon, though, all of this was left behind as I married, divorced, worked my way through nursing school, and became a nurse.

Ernst and I met as newly, somewhat shell-shocked, divorced people. One of our most memorable dates was a van Ruisdael (who?!) opening at the MFA. Upon entering the gallery I was welcomed by landscape paintings of infinite Dutch skies and piles upon piles of dramatic clouds. To me they were alive. Clouds have always been important to me. As a child I would lie in the grass and study them. I told people I could see the molecules that composed them. Clouds gave me great solace and calm during distressing times. At that exhibit I began to understand how representational paintings were also involved in harmony and balance, composition and color, and held their own sense of geometry.

When Ernst and I met he had just begun to take up oil painting again, and, although he wouldn't say so, he is quite good. Ernst was greatly influenced by his mother, also an amateur painter. Growing up in Holland surrounded by centuries of important artists must have also inspired him. (I heard that in the 1700s some Dutch households displayed three hundred paintings on the walls of their homes. I believe it!) Ernst has been my art mentor and my educator through our thirty-three years of marriage. I have come to appreciate and am attracted to the application of paint and the essence of light in paintings.

The basis of how I collect is my emotional reaction to a piece. I've enjoyed many a sublime moment. Early on, Ernst collected paintings by Richard Sheehan, who captured light and atmosphere of such Boston neighborhoods as Hyde Park. I don't recall the order from there as we collected more paintings, including Nicks, Rahillys, Monafos to name a few, all very painterly, rich in textures, balanced in composition, both

plein air and studio paintings. I've been privileged to meet many of the artists whose work we collect, and the joy of their friendships has enriched my life.

We sometimes collect together, but Ernst will usually check in on galleries, and now online, to keep abreast of our favorite artists, who are from Boston and its suburbs as well as from the North Shore of Massachusetts. Rarely, he will purchase a painting that I'm not crazy about and agreeably hang it in the Salon des Refusés, a small area in his office where he spends much more time than I.

I hope that you will enjoy our collection. As the title of the exhibition suggests, this is art as we see it, and you as a viewer needn't agree!

I would like to thank Douglas Hyland, who retired last year as director of the New Britain Museum of American Art, for his excitement about our collection and for inviting us to exhibit it. I also would like to thank Min Jung Kim, the present director, and her colleagues, who have embraced this project with enthusiasm. Selecting paintings from our collection and putting together a catalog for the show has been a continuation of our art experience and another step in learning how the art world works.

A CONCERN FOR PAINTERLY RESPONSE

KATHERINE FRENCH

When asked about the paintings that he and his wife Gail collect, Ernst von Metzsch graciously insists that anything he might have to say is less important than the art itself. In fact, wide-ranging experience informs the choices he makes: childhood visits to the Rijksmuseum in Amsterdam with his mother; graduate studies in geology and economics at Harvard that led to a professional relationship with the Boston art collector Stephen Paine; and finally, friendships with artists who invite the couple into their studios to see work before it is finished. Ernst and Gail are clear that paint and the painting process are what concern them; yet those fortunate enough to view this collection will not only find paintings that reveal process, but also a body of work that has a lot to say.

The couple enjoys what the poet Mark Strand called "the art of the real." Focusing on representational painters who are living, they began collecting together in the 1980s, purchasing urban landscapes before turning their attention more broadly to local artists who interested them. When Ernst discovered that George Nick was painting in the Charlestown Navy Yard a short distance from his office on State Street, he walked over and knocked on the door of the truck Nick had converted into a mobile studio. That conversation, the first of many, resulted in an invitation for the artist to come and work near their seaside home on Cape Ann north of Boston - much to Gail's concern when she later watched Nick scramble over the slippery rocks. But these are collectors who do not limit their vision to what they can see by looking out the window. Less concerned with subject than painterly response, they are interested in works that explore realism and certain qualities of light, and in getting to know the artists personally.

Descriptive painting depends upon light. Edward Hopper once remarked that that all he wanted to do was "paint sunlight on the side of a house," a statement that resonates when looking at paintings in this collection. Ernst began purchasing work by Richard Sheehan from Boston's Alpha Gallery in the 1970s. *Summer Street*, *Hyde Park* and *Dana Variety* (both 1978) might depict places that were familiar to the artist, but are really about the sun at a specific time of day. Sheehan, a Dorchester native who studied with George Nick at the Massachusetts College of Art (Mass Art) before going on to Yale, was admired for working outside despite the weather, wearing a thinner glove on his painting hand to give him flexibility. Winter paintings were gray and bleak, but the owner of his San Francisco gallery joked that it might be possible to catch a tan just from standing next to one of his summer canvases.

Ernst and Gail have been consistently attracted to warm light. *Red Building in Autumn* (1983) by George Nick was an early purchase, along with Sheehan's urban landscapes, that one critic called an occasion for visual poetry. They take similar pleasure from the raking light of late afternoon, as in Scott Prior's *Yellow Chair* (1988) and Ed Stitt's *173 Marlborough Street* (1993). The couple finds the late artist Sarah Supplee "dramatically non-European"

for the red underpainting in *Above Copake* (1996) and other works that "makes her pictures glow." They also delight in the direct blast of midday sun in Eric Aho's *Small Parsonage* (2006), as well as the warm brick on the side of a building in Ben Aronson's *Street Corner, Manhattan* (2006).

Having grown up in the Netherlands, Ernst notices differences between the Dutch paintings he saw as a child and the work he now actively collects. "There's more water in the air in Europe," he remarks when pausing to consider landscapes inherited from his sister. "You can't make those paintings in New England." Yet, he enjoys looking at Dutch art, mostly for its evocation of atmosphere, and on visits home he notices clouds much like those that would have appeared to painters in the 1600s. Gail agrees. "The light in Holland is like a vapor," she affirms. It makes things "feel less heavy." Yet, it was precisely a sense of heaviness that attracted the couple to the work of Bernard Chaet, a summer neighbor from nearby Rockport who taught painting at Yale. *Hovering Clouds* (2002) and *Salt Air* (1995-2003) bear witness to Chaet's experience of studying with the German Expressionist painter Karl Zerbe at the School of the Museum of Fine Arts, Boston (the Museum School). They also point to Ernst and Gail's willingness to explore the many different kinds of painting that exist under the large umbrella of contemporary realism.

Chaet was a member of a talented generation of painters that included Hyman Bloom and Jack Levine, "the bad boys from Boston," whose provocative work held sway over the national art scene in the late 1940s. Chaet and his contemporaries painted in ways that eventually gave rise to abstraction, but were determined to paint representationally. In fact, the artists who came to be known as Boston Expressionists were tenacious: no matter how free or gestural the brushwork, viewers could always discern a figure, a place, an object. When Boston Expressionists were eclipsed by the very abstract painters they'd inspired, Chaet left to teach at Yale, but most of his classmates remained, selling to area collectors through local galleries and influencing subsequent generations of painters by teaching in programs at the Art Institute of Boston, Boston University, Brandeis University, Mass Art, and the Museum School. This set the stage for a strong tradition of representational painting, with redoubled interest from a new generation of collectors, around the time Ernst began to acquire art.

Artists were reluctant participants in the critical battles that raged during the 1950s. They mostly wanted to keep their heads down and work. However, figurative painters earned the solid respect of many Abstract Expressionists. When critic Clement Greenberg argued that it was impossible to paint a face, artist Willem de Kooning countered that it was impossible not to and even went on to praise Hyman Bloom in a speech to Chaet's students at Yale. Edwin Dickinson and Fairfield Porter helped Hopper keep representational painting alive during the "figurative fifties," and a following generation saw continued figuration as more radically important to painting than abstraction. Bernard Chaet, William Bailey, and Neil Welliver taught at Yale, and Welliver invited Porter to visit. Dickinson was hugely influential to those who studied with him at The Art Students League of New York; his students included painters like Lennart Anderson and, more importantly for Ernst, George Nick.

Nick's clear definition of light was immediately attractive. Seascapes by Chaet encouraged Ernst and Gail to explore a liking for thick impasto and more expressive work. The couple went on to acquire paintings of the Maine coast by Jon Imber and John Walker, as well as Vermont landscapes by Eric Aho. Imber's *Tidebreak-Two Spruce* (2008-2011) pays homage to de Kooning while revealing an island set between sea and sky. Walker's paintings of a tidal mud flat on bingo

cards, *Harrington Road Series #16* and *#28* (both 2010), are abstractions informed by observation. The landscapes of Robert Ferrandini, Julia von Metzsch Ramos, and Lucette White are mystical, poetic, and thinly painted, while Sedrick Huckaby's *Self Portrait* (2008) displays an affection for a lush surface of thick paint, as does Nick's later work. Aho's *Surveyor* (2006) employs a wide range of paint application inspired by the English painter John Constable whom Aho credits with an understanding that painting "doesn't have to be precise, but it has to be accurate."

Aho is not the only artist in the collection who admires Constable. On the first day in Chaet's freshman painting class at Yale, Richard Raiselis was invited to choose from his teacher's collection of reproductions, which included several Constables, and then speak about them. Everyone was asked to do it - Chaet saw it as a good way for students to get acquainted and for him to understand their interests. But a seemingly random choice of two cloud studies by Constable presented Raiselis with a challenge that has remained a constant throughout his career - the problem of how to paint a "moving mass of water vapor."

Admired by both realists and romantics, Constable lived in an age of scientific discovery tempered by emotion. Turning attention to clouds only twenty years after Luke Howard, a London chemist, established a system of precise classification and assigned Latin names to clouds, Constable was careful to record times and weather conditions on the back of his canvases (much as George Nick inscribes the date of completion into wet paint). But he also embraced the romantic impulse of his contemporaries. While Constable was in London looking up at the sky over Hampstead Heath, J.M.W. Turner was on the south coast interpreting atmospheric effect. In Germany, Caspar David Friedrich refused Goethe's offer to illustrate scientific cloud studies, but went on to project his melancholy onto a sea

of fog. In the remote reaches of the English Lake District, William Wordsworth reflected on walks taken together with his sister Dorothy by writing that he wandered "lonely as a cloud."

"There are no more truthful images of clouds than those painted by Constable," wrote art historian Ernst Gombrich in his book *Art and Illusion* (1960). Aho admires the English painter for his deep knowledge of the landscape and how it worked, "from its agrarian purpose to its atmospheric incident." But while Constable was engaged with clouds for scientific observation, he also believed in the sky as a landscape's "chief organ of sentiment." Leaving the studio to work directly from nature, his brushwork became looser, more expressive. Critics point to heavy clouds as visible signs of grief over his wife's death, but it's Constable's tendency towards precise observation that resonates with realist painters today.

Raiselis never followed Chaet down an expressive path, yet he is perfectly willing to mix observation with a desire to personalize. *B.D.* (2010) portrays the self-confident swagger of a big daddy patriarch. *Sundae Cloud* (2009) drifts as a frothy confection, while *Icarus* (2011) begins his precipitous fall from the sky. Realism takes precedence in *Equinox* (2004), his painting of the historic Custom House Tower in Boston's financial district, yet Raiselis acknowledges its romantic component. Finished on the exact day in March when the earth's axis inclines neither toward nor away from the sun, light - really the subject of the painting - is in perfect balance. The equinox is also an astronomical phenomenon during which ancient structures are said to reveal their secrets. And it's the title of a composition by John Coltrane, one that Raiselis, a talented saxophone player, knows well.

Ernst and Gail focus on realist painting, but are not tied to any particular style or subject matter. "I don't care what they paint as long as it's interesting to us," Ernst remarks, noting his and Gail's

embrace of portraiture, still life, and landscape. "Their question is why is it being done," observes Arthur Dion of Gallery NAGA in Boston. "That is what animates their interest. Ernst and Gail really want to know what an artist brings to the table." Often, this means getting to know artists personally. "It adds depth," says Gail. "Knowing painters and hearing them talk about their work and their families gives me a deeper understanding of what they are trying to do."

When interviewed, nearly every artist used the word "genuine" in describing conversations or meals during which much is shared - not only about painting, but also about history and a wide range of other subjects. As a former geology student, Ernst was happy to take George Nick to Magnolia, Massachusetts to discover the light and dark rock formations that Nick eventually painted. Together they searched nearby Folly Cove to find the precise location where the artist Leon Kroll once painted. Going further afield, they traveled to Provence to visit the Bibemus Quarry and Mont Sainte-Victoire, where Cezanne worked.

Two of the artists who have come to expect regular studio visits are Joseph McNamara and Steve Hawley. Hawley sees this as having an effect. "They come to see me," he says. "They are interested in me as a person and in my family and everything that happens in my life. I think that eventually shows in my work."

Hawley studied at the Museum School with second generation Boston Expressionist Henry Schwartz, who taught the trompe l'oeil techniques he'd learned from Karl Zerbe. *Portrait of George* and *Portrait of Julia* (both 2011) display his remarkable ability to achieve likeness, but *White Rose on the Terrace* and *Orchid Outside* (both 2013) hint at his tendency towards abstraction. On one of their visits to Hawley's studio, Ernst and Gail saw a painting that was only water - no horizon, no sky, just a turbulent mass of water. Hawley was using his usual method of building up thin layers of oil, wax, and alkyd resin, but Gail noticed how different this one looked. She mentioned the scientific principal where order becomes disorder, and Hawley appropriated the word as the title for the work that they eventually purchased. "It was very chaotic," Gail remembers when speaking about *Entropy* (2012). "All those ocean currents coming together...it reflected a state of abstraction."

Abstract painting is not normally their thing, nor is work that's unsettling. However, acquisition of Hawley's painting demonstrates a commitment to follow the work of people they respect. Gerry Bergstein, who also studied with Henry Schwartz, is admired for his virtuosic handling of paint and the comic truth found in such paintings as *Location, Location, Location* (2003) and *Climb II* (2006) - both highly detailed, yet anxiously expressive works. They appreciate Joseph Barbieri's quirky invention, as well as Alston Purvis' elegant collage with its occasional snippet of Dutch text. Gail speaks about walking though the house alone and pausing to admire Janet Monafo's beautifully rendered pastel *Open Heart* (1994) for "a feeling of peacefulness, which allows me to think." Quiet contemplation is what shapes their approach to collecting. "Ernst and Gail have respect for themselves," remarks Arthur Dion, "which makes it easy for them to respect others. Both have a sense of calm in relation to their own responses. Consequently, their engagement with art is remarkably unfreighted."

Another way for them to engage has been to try making art. Each has taken private lessons, and Ernst has his own painting studio. In the early 1980s he studied with Yvonne Pène du Bois, daughter of the painter Guy Pène du Bois, who was a close friend of Hopper. Classes happened at her home in Brookline, Massachusetts, which included regular opportunities to view the Hopper painting she'd inherited. Ernst's painting *Route 6 Eastham, 10 minutes later* (1996) pays

homage to a 1941 work by Hopper, but does not convey the painter's inability to relate to people, as described by art historian Gail Levin in her book *Edward Hopper: An Intimate Biography* (2007). Arthur Dion observes that both Ernst and Gail are curious about "how painting communicates what it means to be human." By placing a figure on the scene, Ernst indicates that no matter how beautiful the light, the sudden appearance of a man on a motorcycle is compelling.

Many artists in the collection eschew the camera as a tool, but Joseph McNamara refuses to avoid "the influence of the photographic age." He's taken pictures from the catwalk above the pens at a cattle auction, hung from a helicopter, and looked up from inside a missile silo, yet doesn't refer to himself as a photorealist. Instead, he employs the materials and techniques of Flemish masters to create what he calls "technoscapes." Using a grid to build highly detailed paintings of construction sites - or in the case of *Yankee Stadium Demolition* (2014), deconstruction sites - McNamara crafts scenes that are not traditionally scenic. In *Vermont (E.L. Smith Quarry)* (2014-2016) the earth has been cut away. In *Shreveport Scrap and Salvage Depot* (2010-2011), the viewer is directed to look at piles of rusting metal. Yet while willing to take a camera into uncomfortable places, McNamara will not set up an easel outdoors. Although he grew up in Somerville, Massachusetts, and took classes at the Museum of Fine Arts, Boston before getting a BFA from Mass Art, he painted *Charlestown Navy Yard* (2009) in his Manhattan studio, where the light source could be controlled.

For all their similarities, artists in the von Metzsch collection display marked differences in approach. One interest that Joseph McNamara and George Nick share is an engagement with what the 20th century wants to leave behind. McNamara seeks to impose order onto chaos and puts subjects at a cool distance. Nick brings abandoned machinery to the front of the picture plane in such paintings as *Jim's Derelict, Roanoke, VA* (2000) or *1909 Peerless @ Collings, Stowe, MA* (2005). The discovery of a rusting tractor becomes an excuse for Nick to record light, and he will drive for hours to capture the precise angle of the sun when it hits. But despite his energy and wild enthusiasm for painting outside, Nick is remarkably accepting of dissimilar ways of working. "Every painter has the same tools, but they react differently," he says philosophically. "That's what makes a picture."

Although unwilling to hold forth, Ernst has definite ideas about art. A lover of fact, he responds to descriptive rather than narrative works, which are two approaches examined by the art historian Svetlana Alpers in her 1983 book *The Art of Describing*. While Italian painters in the 17th century invented scenes to tell stories, their Dutch counterparts created a realistic inventory of domestic life. Suzanne Vincent's portrait of the von Metzsch children as teenagers is an updated version of this impulse. The wall tapestry, the upholstered chair, the Oriental rug on the floor: all decorate the room where Julia and George sit waiting to become adults. However, the real subject is the clarity of vision that describes them. Paul Rahilly is similarly engaged with the appearance of forms. *The Violinist* (1980) and *Figures with Rolled Paper* (1982) cannot be read for complex meaning, and it would be hard to make logical sense of the geese running around in *Bill Hynes with Violin* (1994). Rahilly is in love with the tactility of material. Well-painted objects do not interpret the world, but rather allow us to see it through an aesthetic lens that Rahilly holds up.

Alpers wrote about a culture obsessed with how visual information was recorded: Vermeer may have experimented with the camera obscura, while his neighbor van Leeuwenhoek worked to improve the optical lens. One of their contemporary counterparts might be Harold Reddicliffe, who considers the act of looking to be his most important job. Despite the hyper-real appearance

of *Cigarette Lighter with 44 Squares* and *Cigarette Lighter on Plant Stand* (both 2006), Reddicliffe does not use a camera (although cameras, magnifying glasses, and microscopes often serve as subjects). Yet, while one might think that Ernst and Gail's enjoyment of clearly defined picture-making would have led them towards photography, their primary focus is painting.

In 2013, on a collectors' panel moderated by the newly-appointed Fitchburg Museum director Nick Capasso, Ernst remarked that he and Gail are most "interested in the ability of an artist to communicate" and are profoundly interested in knowing "how artists see and...how they look at things." Together, they seek an experience based on looking, much in the same way painters examine the work of other artists. When Catherine Kehoe attended the recent Museum of Fine Arts, Boston (MFA) exhibition *Class Distinctions: Dutch Painting in the Age of Rembrandt and Vermeer*, she was "just dazzled by the silk dresses" and made a "transcription" of Gerrit ter Borch's *The Messenger* - the second such work Ernst and Gail have acquired. In 1994 Ed Stitt got permission from the MFA to make a copy of Diego Velázquez's portrait of Luis de Góngora, meticulously working to understand exactly what colors the Spanish painter had used in his palette. Stitt and Kehoe both studied at Mass Art with George Nick, who encouraged this tendency towards careful looking and learning. "From George," says Kehoe, "it was possible to learn how very mysterious the act of seeing can be."

Ernst and Gail have learned this lesson from the many artists they've been privileged to know, and their daughter Julia, an accomplished painter in her own right, is grateful for the upbringing she enjoyed. Even as a child, she was invited to accompany her parents to gallery openings and on studio visits. At dinner the whole family would talk about the exhibitions they'd seen, and Julia remembers wandering through the house to find Ernst on a ladder arranging paintings. "The act of seeing is like reading a book for them," she says about her parents. "Looking at, thinking about, and discussing painting has become their way of life."

"My parents respect artists," she goes on to say, "and the world that surrounds them. That's what they are proud to have on their walls." Julia's words help crystallize an observation about the unpretentious nature of this collection. Ernst and Gail collect in a focused manner, choosing to own many paintings by a few artists, instead of a smaller number designed to impress. When wondering why they don't acquire a Hopper, a Rockwell Kent, or even a Dickinson, one realizes that their attitude is primarily one of support. If these collectors buy paintings from living artists, then artists can make more paintings. If they purchase through galleries, then galleries will be able to show more work. By collecting, Ernst and Gail can make a meaningful contribution to the kind of art they are interested in seeing and continue to develop their own ability to see - which is really the whole point.

In addition to sources noted above, this essay also draws from conversations that took place between July, 2015 and March, 2016 with Ernst and Gail von Metzsch, as well as with artists, art historians, collectors, and gallery owners, most notably Eric Aho, Ben Aronson, Gerry Bergstein, Arthur Dion, Joanna Fink, Steve Hawley, Pat Hills, Catherine Kehoe, Joseph McNamara, Janet Monafo, George Nick, Susan Paine, Paul Rahilly, Richard Raiselis, John Stomberg, Julia von Metzsch Ramos, Ed Stitt, and Meg White.

Katherine French retired as director emerita of Danforth Art Museum/School in Framingham, Massachusetts in 2015 and now works as a free-lance curator and writer.

THE PAINTINGS

WHAT WE'VE ENCOUNTERED

Of a few painters in our collection we own too much work to show it all properly, with few regrets, and of some others we own maybe only one, often with some regrets. A number of the paintings we like are hard for us to describe, which, in our view, has little to do with their artistic merit. Several of the artists in this exhibit we know quite well, and others not. These notes can be summed up as anecdotal insights into what we've encountered collecting art.

I have always enjoyed reading good biographies of painters. The interesting ones provide a lot of detail on the world these artists lived in, their interactions with their families and other artists, and the technical issues they dealt with. Biographies that tell you how great and admirable the work is, and what one should see in the paintings, are boring. I have tried to emulate the former approach in these notes, and possibly some are interesting for the reader. The purpose of showing this work is to help the viewer think about what strikes him or her visually and not to promote what we like. So if you enjoy browsing through this catalog and are more interested in looking at the images than in reading the text, we have achieved our goal.

We have included reproductions of more paintings than actually can be shown in the exhibition. The catalog has more space, and we like sharing these images with you. Gail and I own other paintings as well, but feel that having focus makes the exhibition and catalog more interesting.

Ernst

ERIC AHO

born 1966

We purchased our first paintings by Eric Aho in 2006 in Boston. I don't remember how we discovered his work, but what immediately attracted me was his ability to paint clouds in a believable way. Clouds are abstract forms. They reflect the light around them in a variety of ways, depending on the time of day and the character of the land or sea surfaces below them. It appears rather straightforward to put them on the canvas, as it looks like you can get them right without too much effort at drawing. The opposite is true, as it is very hard not to make them look awkward. Many painters avoid drawing attention to clouds in their paintings for good reason. Without being able to explain why, I think Aho is successful in moving towards abstraction because of his ability to come up with interesting skies in a representational manner.

For me it has been a challenge at times to follow Aho in his development. I recall buying *Surveyor* (2006) a couple of years after it was made because I thought (correctly, as it's happened) that Aho was going to stop making paintings in this manner. I have gotten into this habit of developing an appreciation of Aho's development a year behind him, and then discovering that catching up has turned out to be very rewarding. *Wilderness (Summer 1903)* (2008), inspired by Aho's Finnish ancestry, is, for me, the point when abstraction got the upper hand. I bought *Seam* (2009) in New York the year it was painted. Aho had an exhibit at DC Moore Gallery, mostly of paintings with fires in snow-covered woods, and there was some anxiety among those who knew him whether collectors would want any of these in their living rooms. Part of my motivation for buying his painting was that, while it looked interesting, I felt I had to support Aho in a crucial moment in his career. The show was a success, and now I look with great enjoyment at this painting a couple times a day in my house. *Son* (2013) still has some representation, but is mostly abstract, and keeps me thinking about what will happen next.

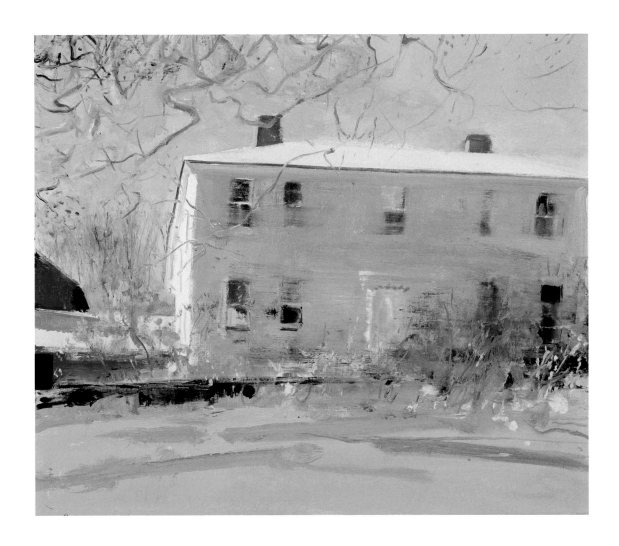

ERIC AHO *SMALL PARSONAGE*

2006 oil on linen 30x36"

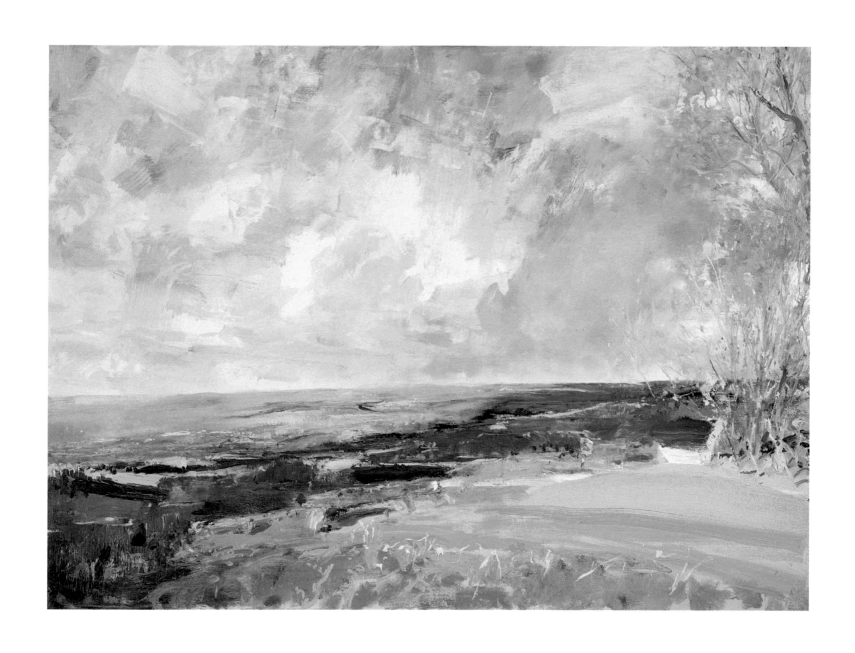

ERIC AHO *SURVEYOR*

2006 oil on linen 50x70"

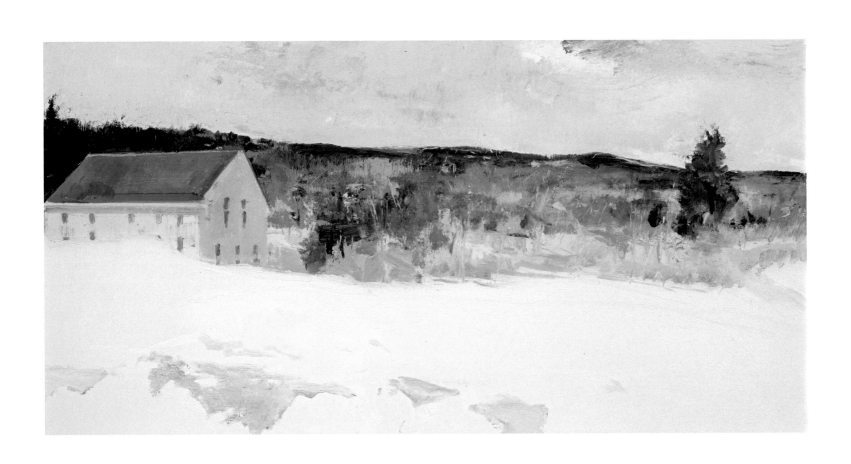

ERIC AHO *GUILFORD SLATE*

2008 oil on linen 25x50"

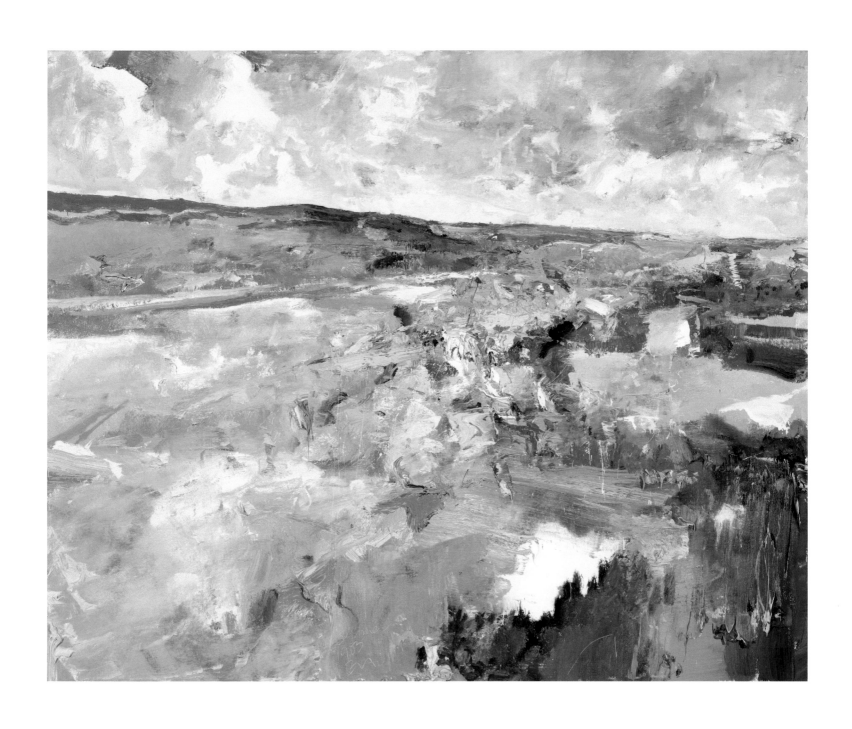

ERIC AHO *WILDERNESS (SUMMER 1903)*

2008 oil on linen 40x50"

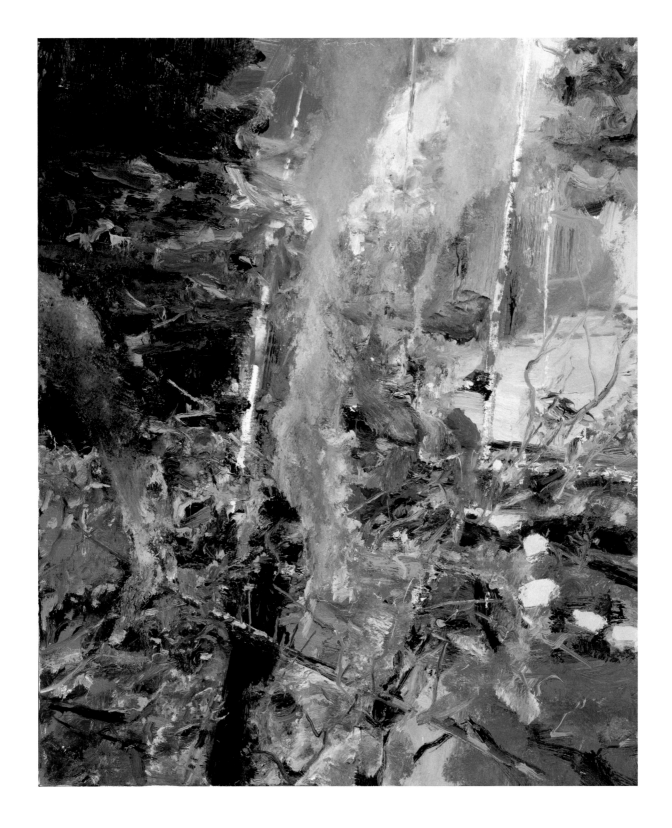

ERIC AHO *SEAM*

2009 oil on linen 36x30"

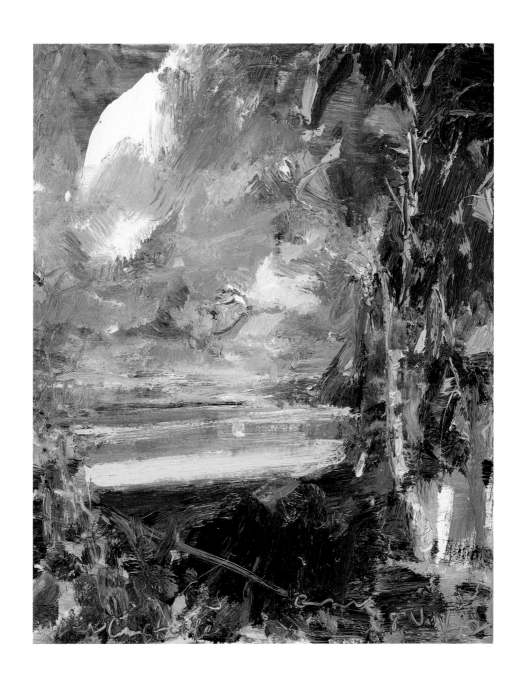

ERIC AHO *AFTER CONSTABLE'S STOUR VALLEY*

2012 oil on linen 20x16"

ERIC AHO *THE FRONT*

2012 oil on linen 36x30"

ERIC AHO *SON*

2013 oil on linen 48x68"

BEN ARONSON

born 1958

Aronson paints city scenes, often in San Francisco, New York, Paris, and Boston, and I also know him for his work of interiors on Wall Street. The paintings are very loose in terms of the way the paint is put on, but are pulled together by touches of detail that make them very interesting to us. They are painterly and intricate at the same time. One interesting aspect of his painting is that, through the atmosphere in the work, the city in which it is painted is quite recognizable, even though the particular location is not.

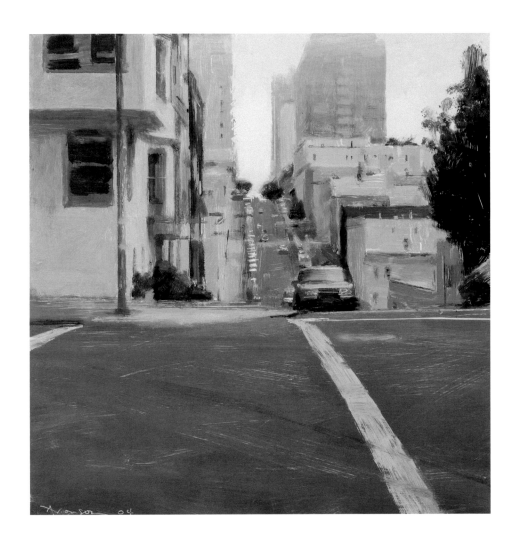

BEN ARONSON *RUSSIAN HILL, SAN FRANCISCO*

2004 oil on panel 12x12"

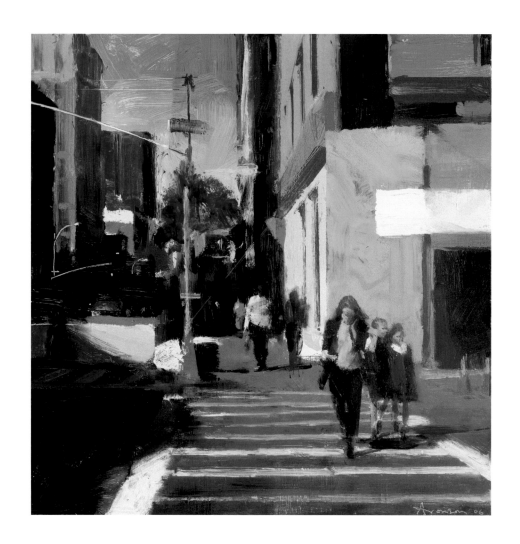

BEN ARONSON *STREET CORNER, MANHATTAN*

2006 oil on panel 12x12"

BEN ARONSON *RUE DU ROI DE SICILE, PARIS*

2008 oil on panel 12x12"

BEN ARONSON *FINANCIAL DISTRICT*

2008 oil on panel 12x12"

BEN ARONSON *OCEAN PARK UNDERPASS*

2009 oil on panel 12x12"

BEN ARONSON *STREET IN GENOA*

2009 oil on panel 24x24"

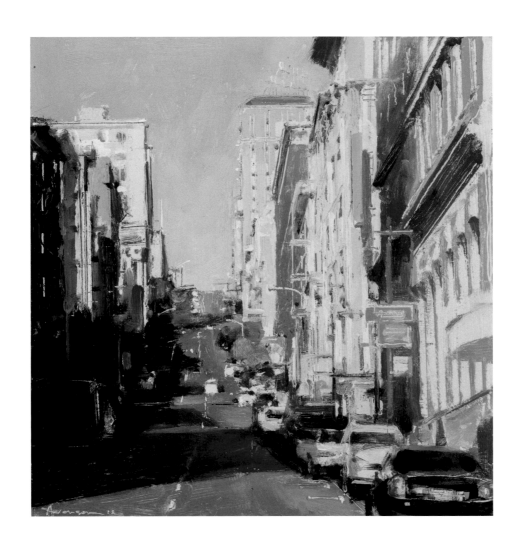

BEN ARONSON *TAYLOR AT GEARY*

2012 oil on panel 12x12"

JOSEPH BARBIERI

born 1941

Barbieri makes paintings of imaginary creatures, with very lively detail, a bright palette, and a psychology that is often lacking in portraits of real people. He also makes landscapes, often in Italy and Maine, which are direct and sensitive in nature and thus in tone quite different from his portraits. Since Barbieri often wears a bow tie, as do many of his subjects, I asked him if these images have an element of self-portraiture. He said no, but I don't think I should believe him.

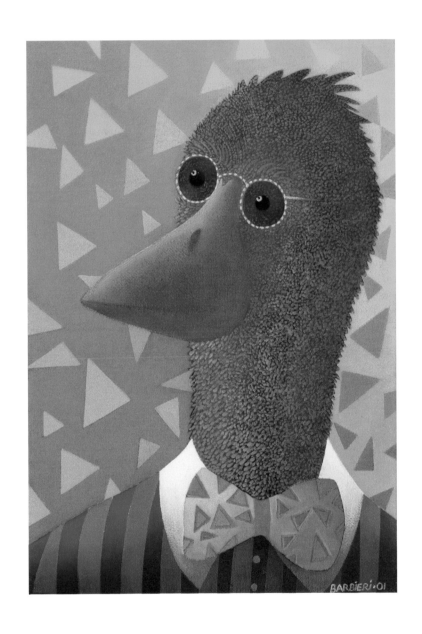

JOSEPH BARBIERI *EQUILATERAL*

2001 oil on canvas 9x6"

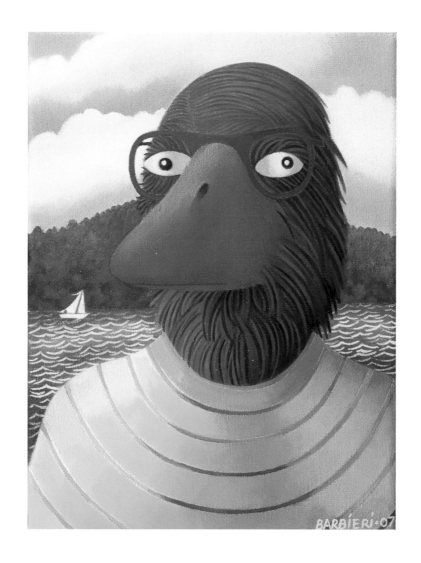

JOSEPH BARBIERI *BLUE HILL*

2007 oil on canvas 8x6"

GERRY BERGSTEIN

born 1945

We have three paintings by Bergstein. I think of Bergstein as having a wild imagination. He is a great master of trompe l'oeil, creates complex images of himself and others in challenging situations, and, in the process, describes the trials of life.

GERRY BERGSTEIN *LOCATION, LOCATION, LOCATION*

2003 oil on canvas 44x84"

GERRY BERGSTEIN *CLIMB II*

2006 oil on paper 30x22"

GERRY BERGSTEIN *PLANET OF THE ARTS*

2007 mixed media on canvas 24x48"

BERNARD CHAET

1924-2012

 We met Bernard Chaet on Boston's North Shore in the 1990s and made studio visits and saw him and his wife Ninon, who is also an artist, a number of times. I recall that when I first went to work at Wellington, a close associate of mine had a light green, pink, white, and orange seascape by Chaet in his office. I wondered why would he want to look at it. Little did I realize that we would become admirers and end up with a large collection of his work. Chaet taught drawing and painting at Yale University, and during summers he and Ninon lived in Rockport, Massachusetts. He was always great to talk to and had a very supportive approach towards our daughter Julia when she started her life in art. Chaet made paintings of many subjects, in an expressionist manner. We own a number of his seascapes and still lifes. Chaet spent a lot of time painting the Atlantic Ocean at the eastern edge of Cape Ann, sometimes reworking his work, large and small, a number of times over a period of years.

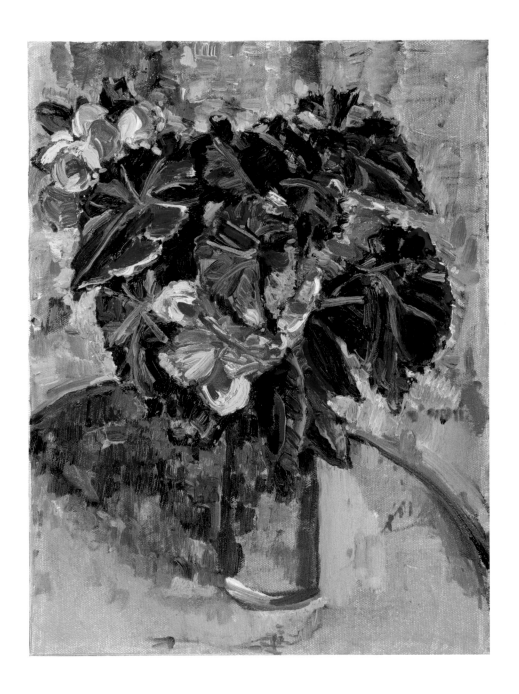

BERNARD CHAET *BEGONIAS*

1993 oil on canvas 14x10"

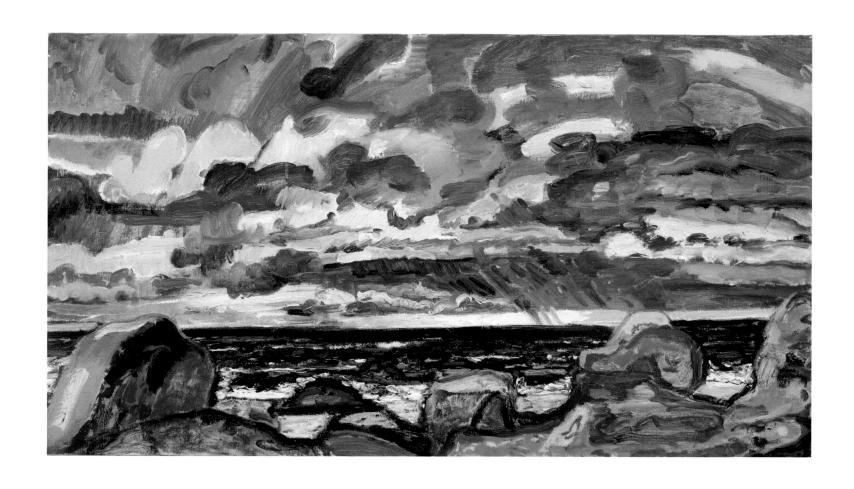

BERNARD CHAET *FOUR YELLOWS*

1993-1998 oil on canvas 18x24"

BERNARD CHAET *DUSK*

2002 oil on canvas 15x30"

BERNARD CHAET *FLOWERS AT THE WINDOW*

2002 oil on canvas 9x11"

BERNARD CHAET *HOVERING CLOUDS*

2002 oil on canvas 12x16"

BERNARD CHAET *SALT AIR*

1995-2003 oil on canvas 36x52"

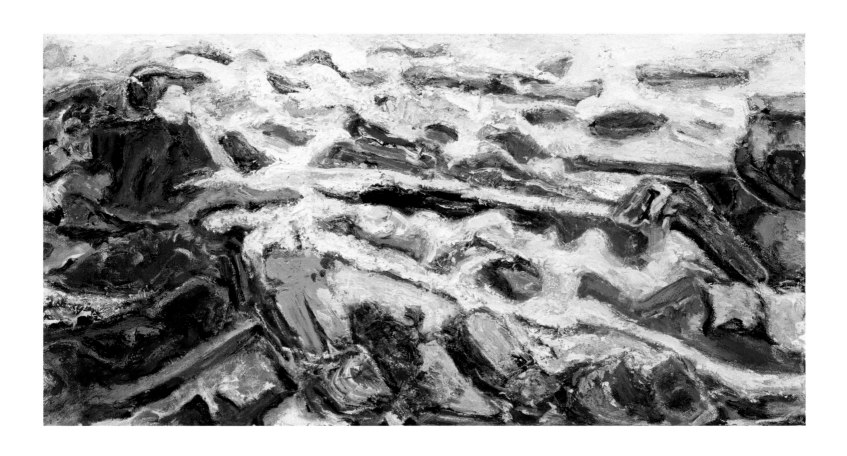

BERNARD CHAET *THE EDGE*

2006 oil on canvas 14x28"

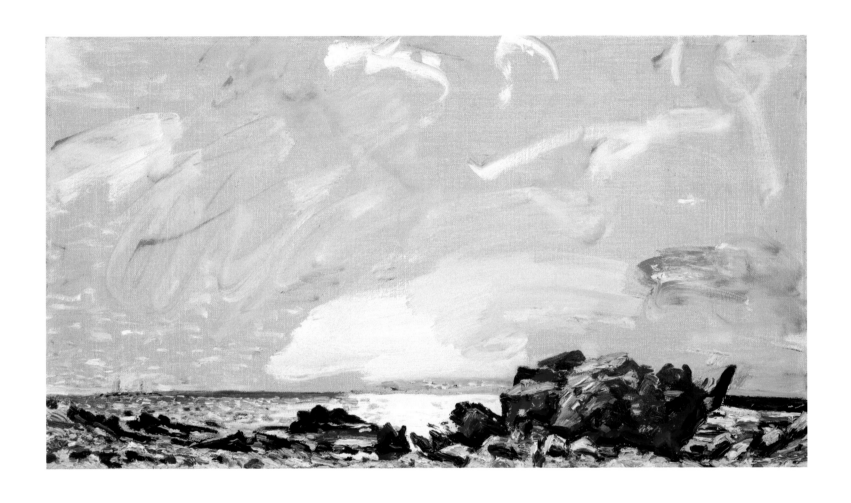

BERNARD CHAET *SUDDEN LIGHT*

2000-2007 oil on canvas 12x24"

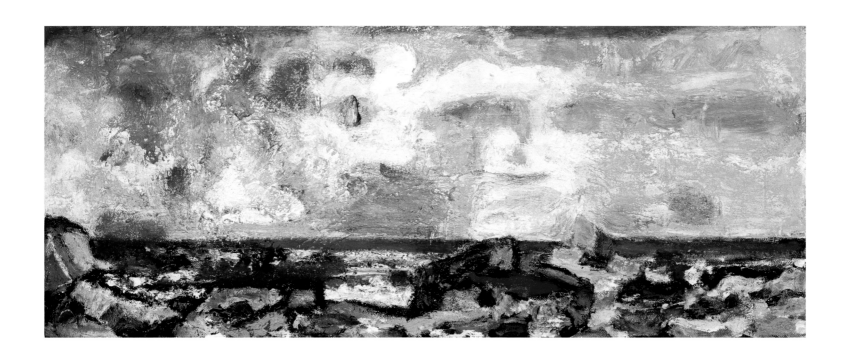

BERNARD CHAET *WHITE WAVE*

1999-2007 oil on canvas 9x23"

ROBERT FERRANDINI

born 1948

Ferradini's landscapes are mystical and rich in fantasy and remind one of places one has been, or dreamt of. They are complex forest scenes that have a remarkable focus. His botany is invented, so the shape and color of his foliage and blossoms are unrestricted by nature.

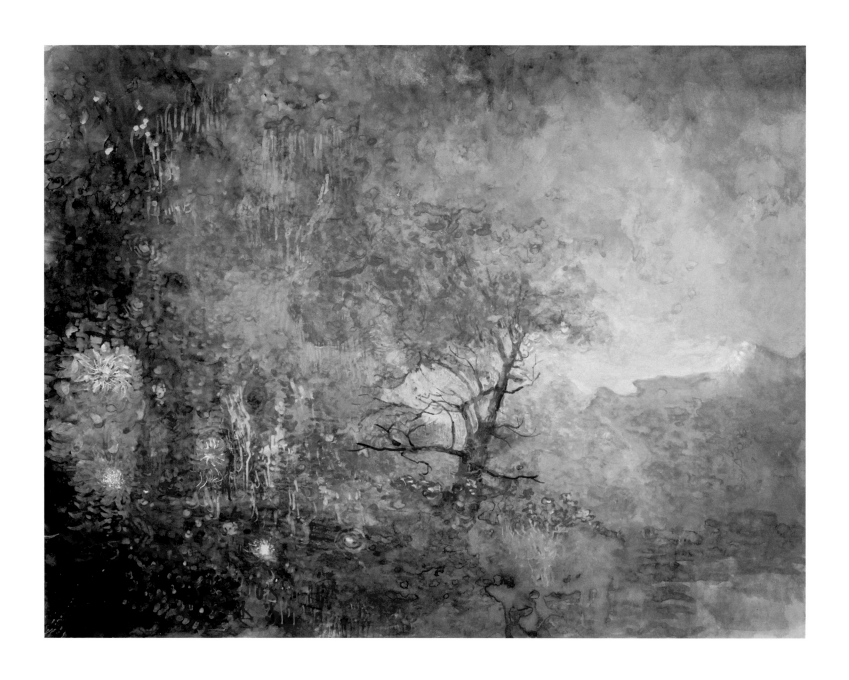

ROBERT FERRANDINI UNTITLED *(5.17.13)*

2013 watercolor and gouache on paper 18x24"

ROBERT FERRANDINI UNTITLED *(9.26.13)*

2013 watercolor and gouache on paper 18x24"

STEVE HAWLEY

born 1950

Steve Hawley lives in Newburyport and has the best-looking studio, in a large industrial building in the middle of town. It is a large space he has filled with easels and tables to work on different projects at the same time. He often paints with encaustics. Hawley has made a number of portraits of our children, Julia and George, two of which are in this exhibit, that bring out the way they look but, more importantly, their personalities in a way Gail and I can recognize. These portraits, like the ones of Roland and George by Ed Stitt, were made at the time they turned twenty-one. Hawley is probably most identified with his portraits, but we also have a number of his seascapes, which come out of his imagination and sometimes veer to the abstract, and a number of his Italian interiors.

STEVE HAWLEY *SUNLIGHT IN SIENA*

2000 oil, wax, and alkyd on panel 22x29"

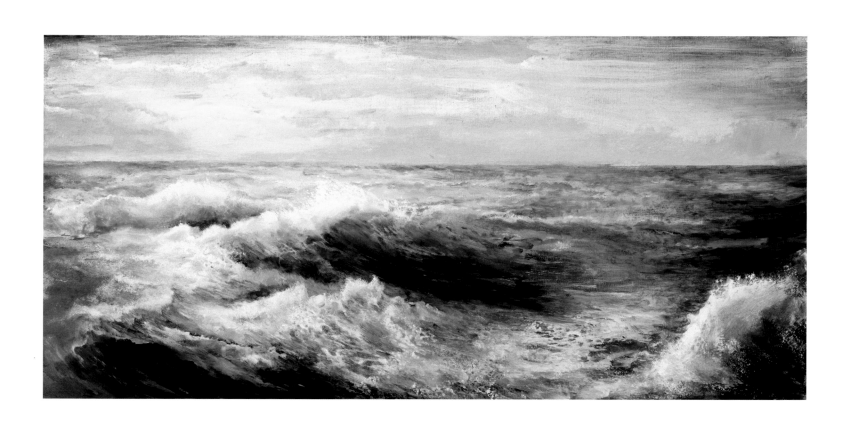

STEVE HAWLEY *ROUGH SEAS 2*

2003 oil, wax, and alkyd on linen 24x52"

STEVE HAWLEY *BRIDGE TO THE PAST (PONTE VECCHIO)*

2007 oil, wax, and alkyd on panel 24x37¾"

STEVE HAWLEY *PORTRAIT OF GEORGE*

2011 oil, wax, and alkyd on panel 38x34"

STEVE HAWLEY *PORTRAIT OF JULIA*

2011 oil, wax, and alkyd on panel 38x34"

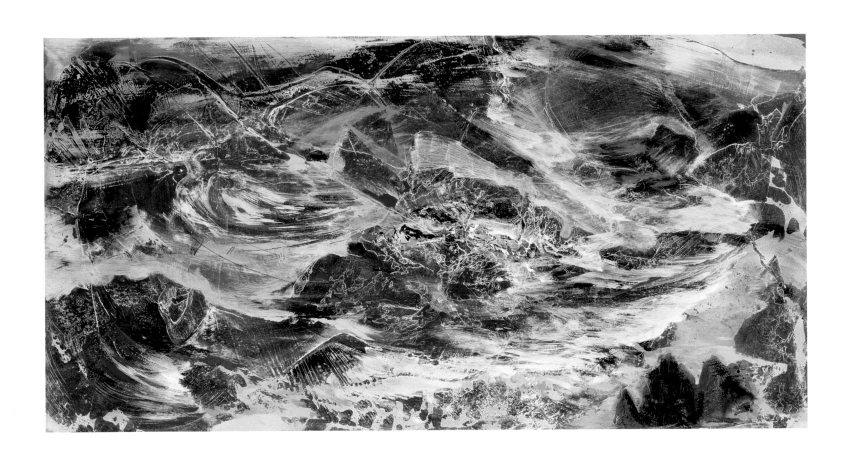

STEVE HAWLEY *ENTROPY*

2012 oil, wax, and alkyd on panel 24x48"

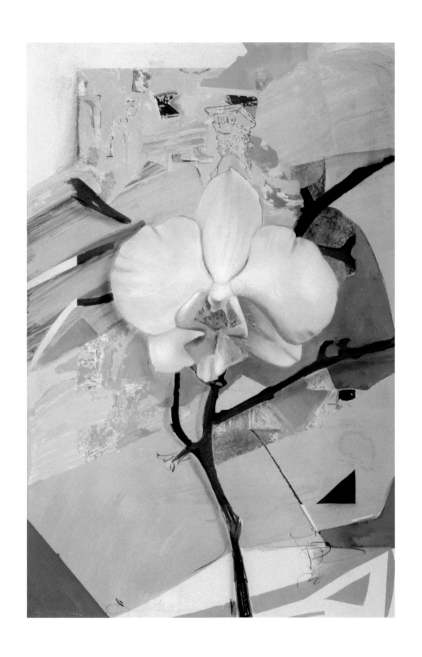

STEVE HAWLEY *ORCHID OUTSIDE*

2013 oil, wax, and alkyd on panel 18¾x12½"

STEVE HAWLEY *WHITE ROSE ON THE TERRACE*

2013 oil, wax, and alkyd on panel 18¾x12½"

STEVE HAWLEY *WARM LIGHT OF ROME*

2015 oil, wax, and alkyd on panel 23¾x35¾"

LINDA HOLT

born 1948

 Holt lives in Magnolia, Massachusetts. She is best known for her paintings of koi, which range from the representational, as shown here, to the abstract. They are very calming, which is perhaps the reason I see them in hospitals which are blessed with good art committees. Her main mentor was Neil Welliver, and his influence is visible in her work. She also makes quite vivid and powerful paintings of dogs.

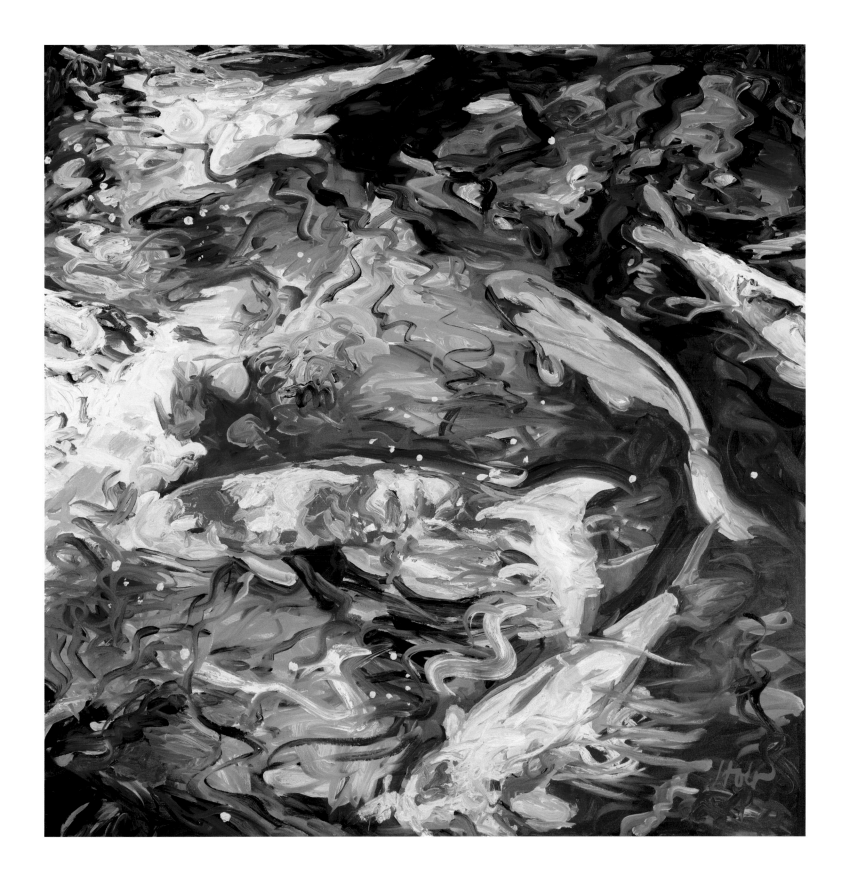

LINDA HOLT *TWISTS AND TURNS*

1999 oil on linen 36x36"

LINDA HOLT *VINCENT AND LILLY*

1999 oil on panel 10x20"

SEDRICK HUCKABY

born 1975

Our daughter Julia introduced us to Huckaby's work. He had gone to school at BU and showed at a local gallery. We have two little pieces of his. Huckaby paints interiors and portraits, but we lost touch when he moved to Texas. The Boston MFA owns a large portrait by him, which would look well in the contemporary art wing.

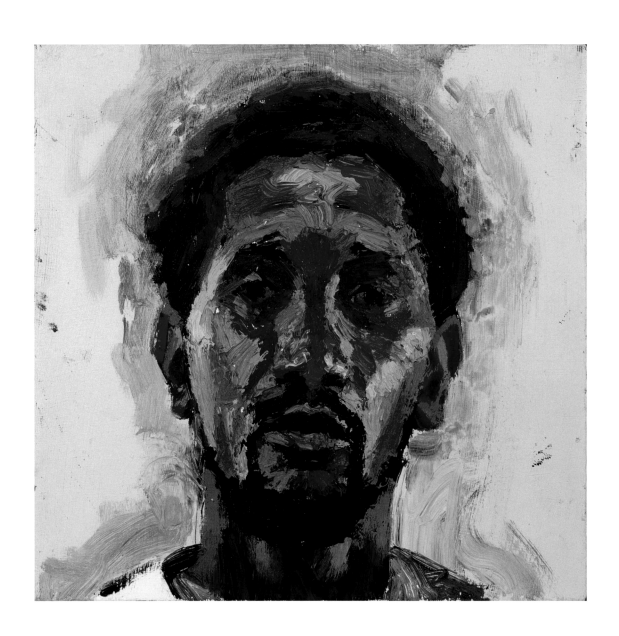

SEDRICK HUCKABY *SELF PORTRAIT*

2008 oil on panel 8x8¼"

JON IMBER

1950-2014

Wellington has a very large painting by Imber, painted in the 1980s, showing farmland in a powerful palette with strong impasto. I was very much taken by it. I remember visiting an exhibit of his work with similar but smaller images and, to my later regret, not buying one. Imber was hard to follow; he would move along quickly, painting what he liked in an evolving manner. *Tidebreak-Two Spruce* (2008-2011) is a painting in a later style.

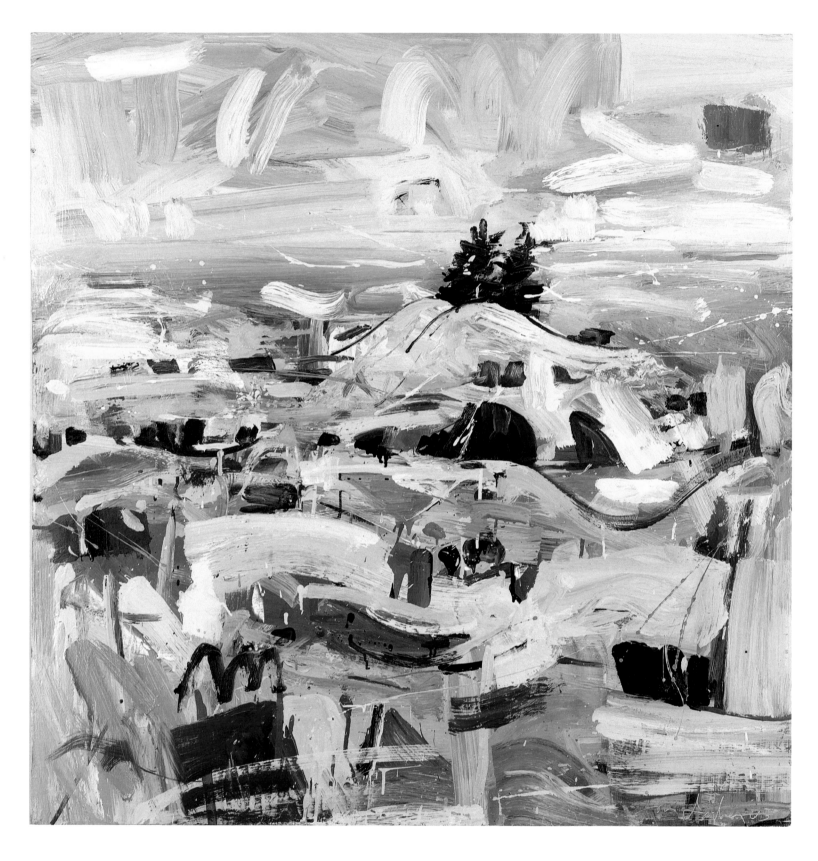

JON IMBER *TIDEBREAK-TWO SPRUCE*

2008-2011 oil on wood 36x36"

ANDY KARNES

born 1984

Karnes went to Boston University's graduate school at the same time as our daughter Julia, and we met him when he had a studio next to hers. His work is quite attractive. Like our daughter, he is at the stage of figuring out whether he has discovered the way in which he wants to continue to express himself on canvas, or whether he will continue developing in new ways. There is a tendency in the art world to wait for an artist to "mature" before you buy. I think that does not have much to do with what's interesting to look at.

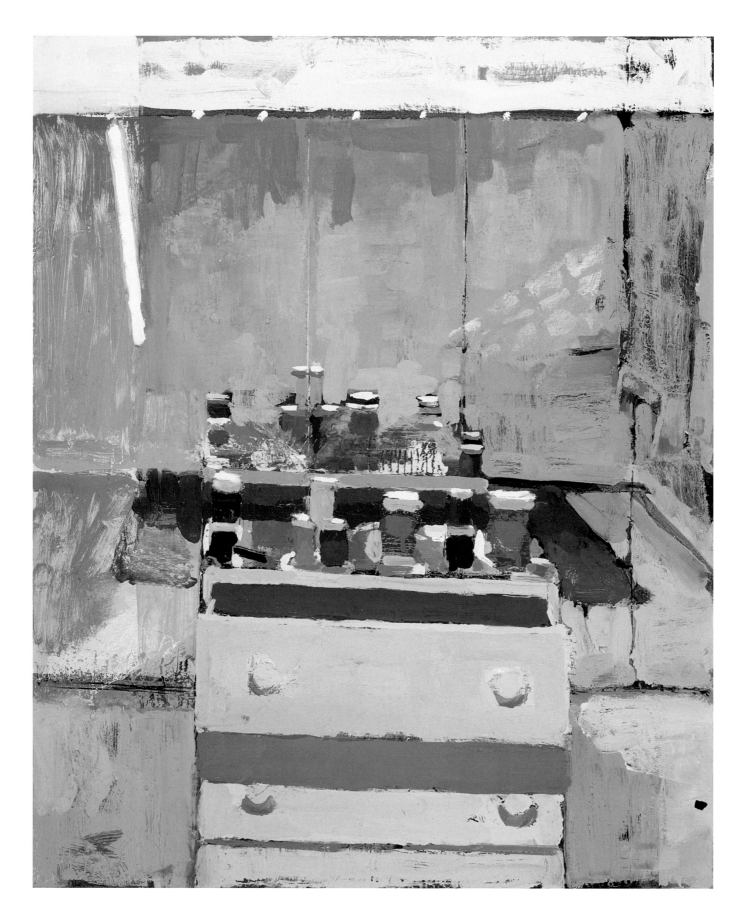

ANDY KARNES *REARRANGED*

2015 oil on canvas 30x25"

CATHERINE KEHOE

born 1956

We met Catherine Kehoe through George Nick and discovered she is a very thoughtful and interesting painter. She mostly makes small portraits and still lifes and is quite knowledgeable about the art world. She runs a very interesting painting blog called *Powers of Observation*. She admires the British painter Euan Uglow (as do I and many painters I know), who has had a great impact on her work.

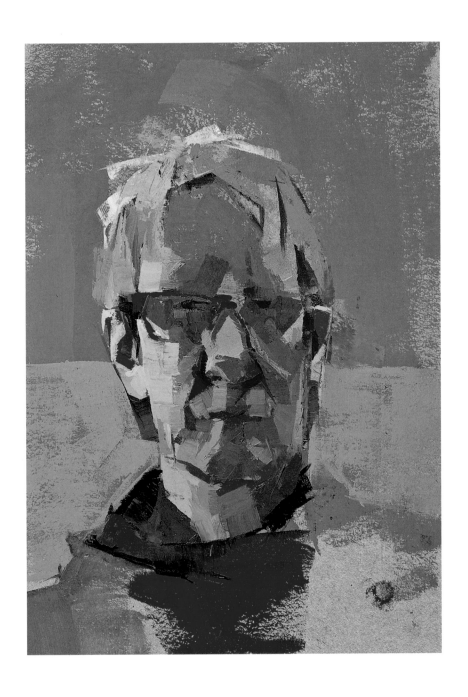

CATHERINE KEHOE *SELF PORTRAIT WITH RED GLASSES*

2010 oil on panel 6¾x4½"

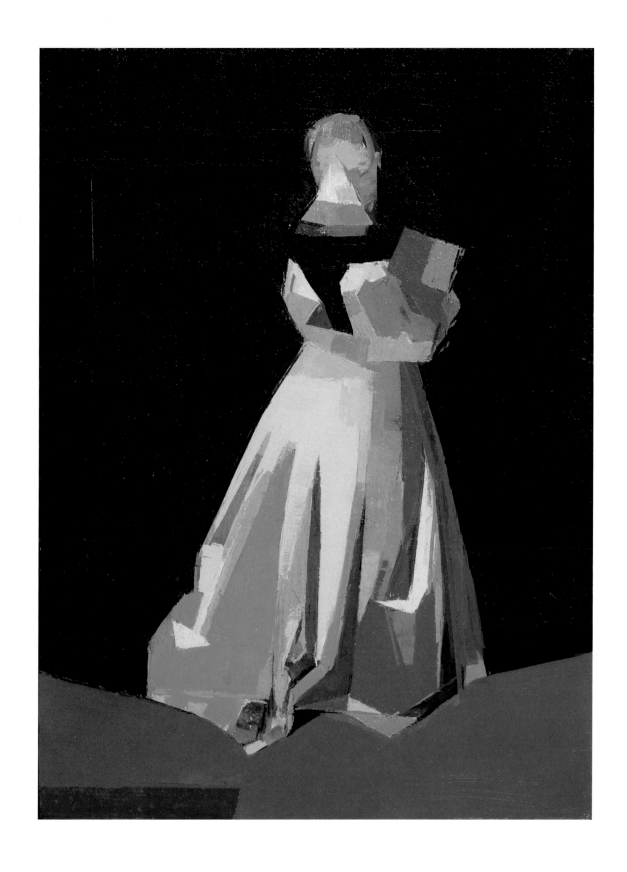

CATHERINE KEHOE *AFTER TER BORCH*

2016 oil on linen on panel 8x6"

JOSEPH MCNAMARA

born 1950

I met Joseph McNamara in New York in the mid-1990s through the erstwhile Stiebel Modern gallery in New York. Joe told me then that he would be out of view for a while working on a commission. I did not hear from him again until 2006, after he completed a series of paintings for the collector Richard McKenzie. Since then Gail and I have become major collectors of his work. McNamara thinks about unusual situations, involving industrial endeavors such as demolition and mining. He travels to sites and then works out what he sees in his studio. Some of these works turn into major tours de force, such as *Yankee Stadium Demolition* (2014), which does not focus much on what's beautiful, but is quite fascinating in showing an interesting composition of piles of debris, with great detail. Who would like to look at a painting such as *Shreveport Scrap and Salvage Depot* (2010-2011) all the time? I do; the painting is great to look at from a distance and chockablock full of wonderful scrap when examined closely.

It should come as no surprise to those in the know that McNamara is a great admirer of the Spanish painter Antonio López García. During a visit by McNamara to his studio in Madrid in 2008, López García told him that he should move to Europe and join his group since "No one in Europe can paint like you." This visit led to the painting *Madrid Interior* (2015-2016).

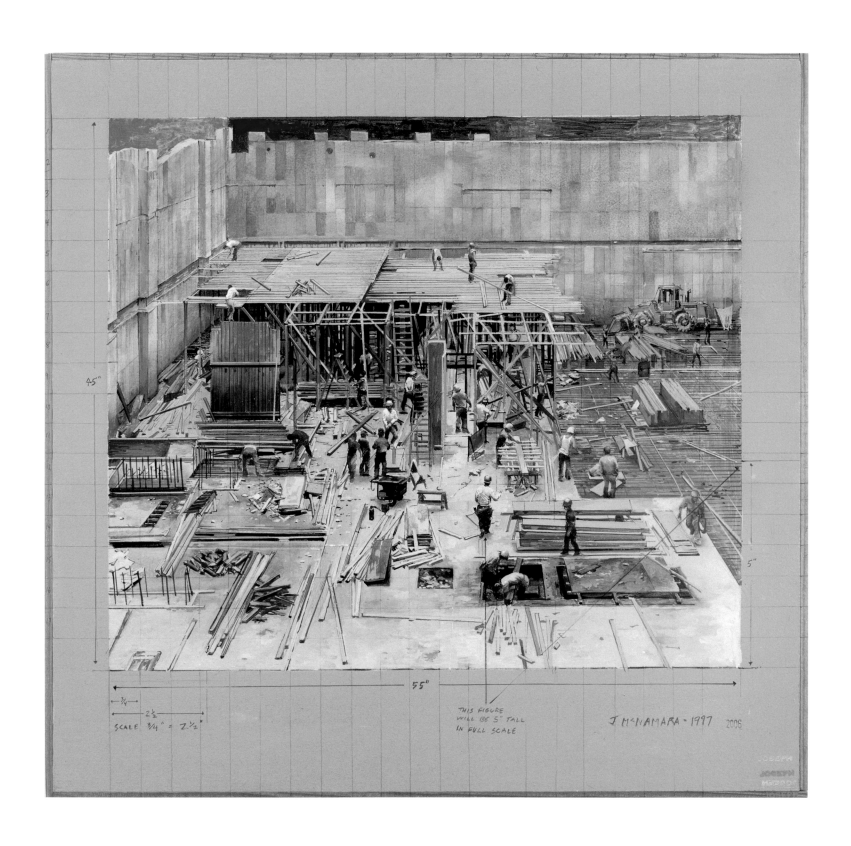

JOSEPH MCNAMARA *STUDY FOR A COMMISSION*

1997-2006 oil on panel 12x15"

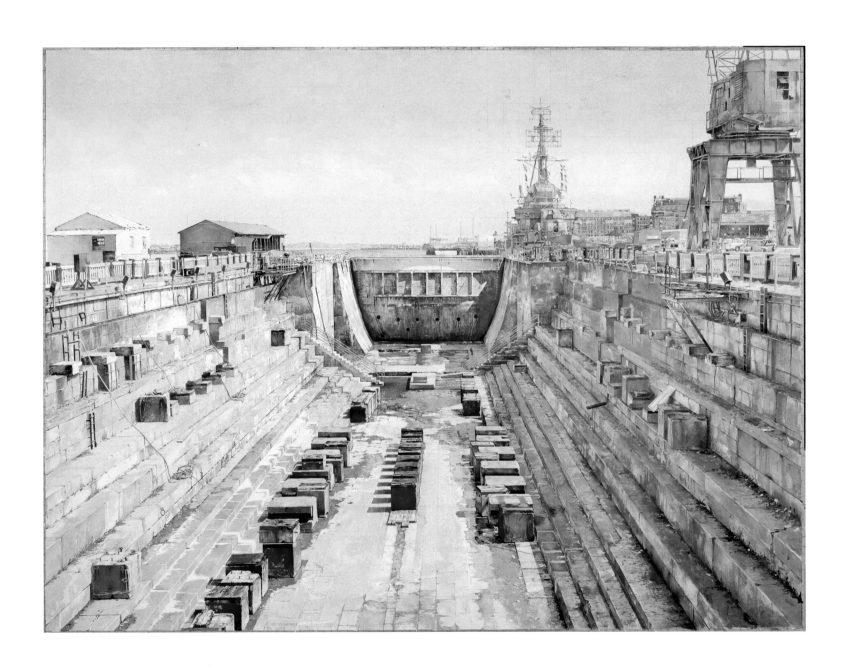

JOSEPH MCNAMARA *CHARLESTOWN NAVY YARD*

2009 oil on panel 42x58"

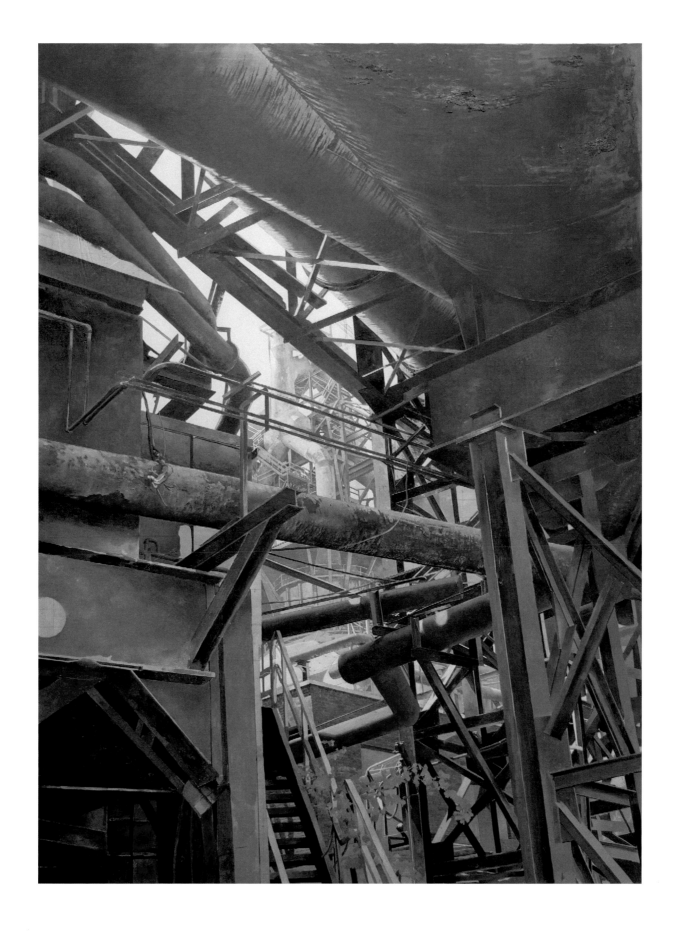

JOSEPH MCNAMARA *BETHLEHEM BLAST FURNACE*

2010-2011 oil on panel 48x37"

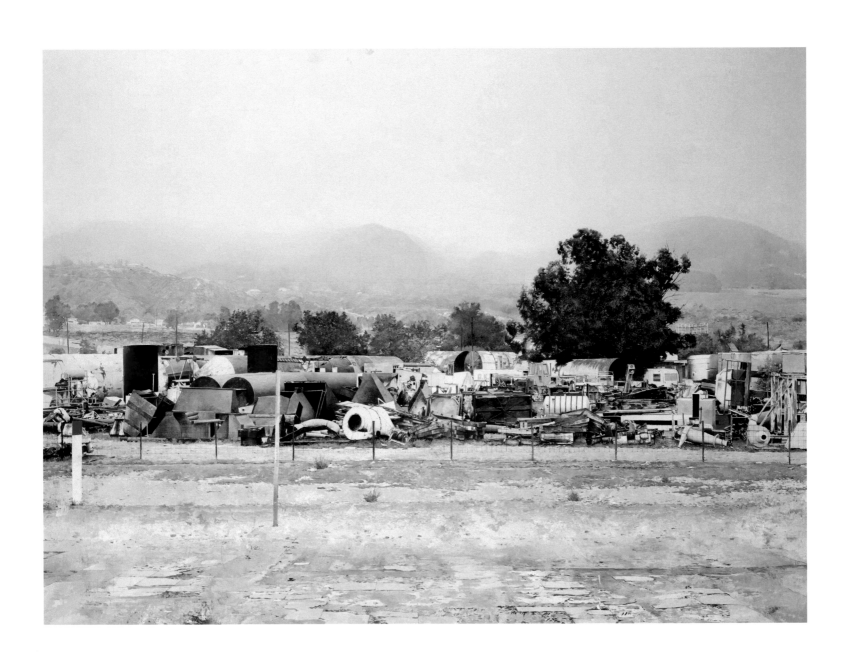

JOSEPH MCNAMARA *SHREVEPORT SCRAP AND SALVAGE DEPOT*

2010-2011 oil on panel 42x58"

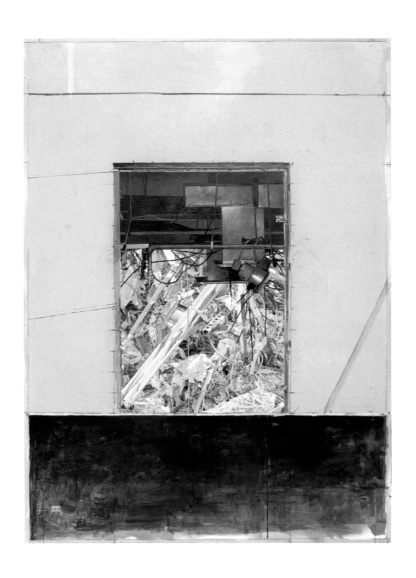

JOSEPH MCNAMARA *WINDOW (YANKEE STADIUM DEMOLITION)*

2012 oil on panel 24x18"

JOSEPH MCNAMARA *COLOSSEUM*

2012-2013 oil on panel 42x57"

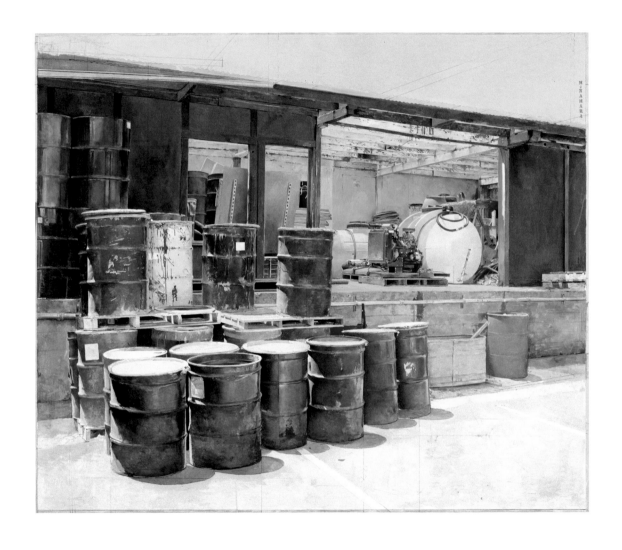

JOSEPH MCNAMARA *GREEN LIGHT*

2013-2014 oil on panel 30x37"

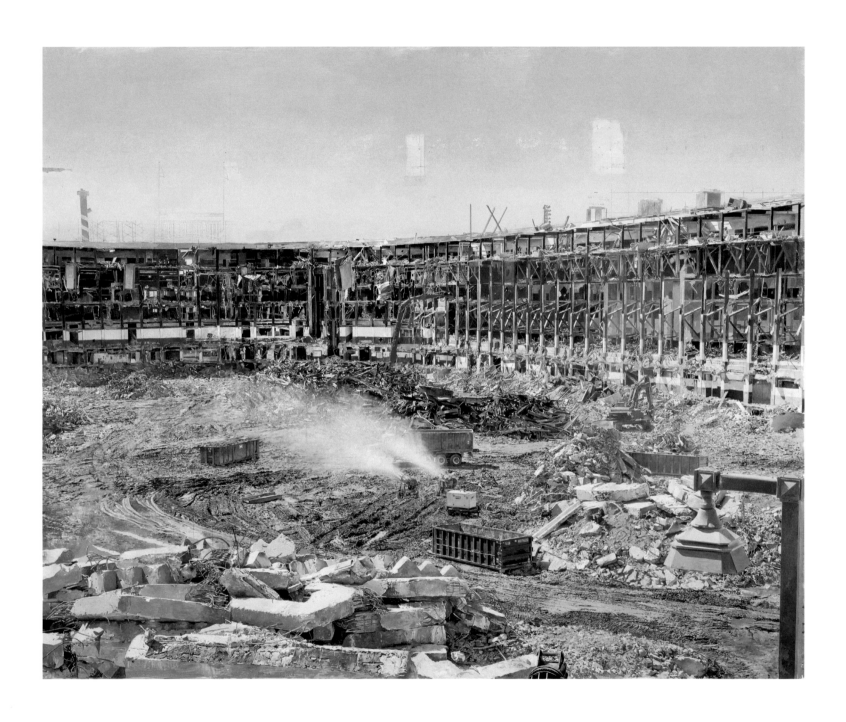

JOSEPH MCNAMARA *YANKEE STADIUM DEMOLITION*

2014 oil on panel 48x62"

JOSEPH MCNAMARA *UN PERRO ANDALUZ (SIESTA)*

2015 oil on panel 7½x12¾"

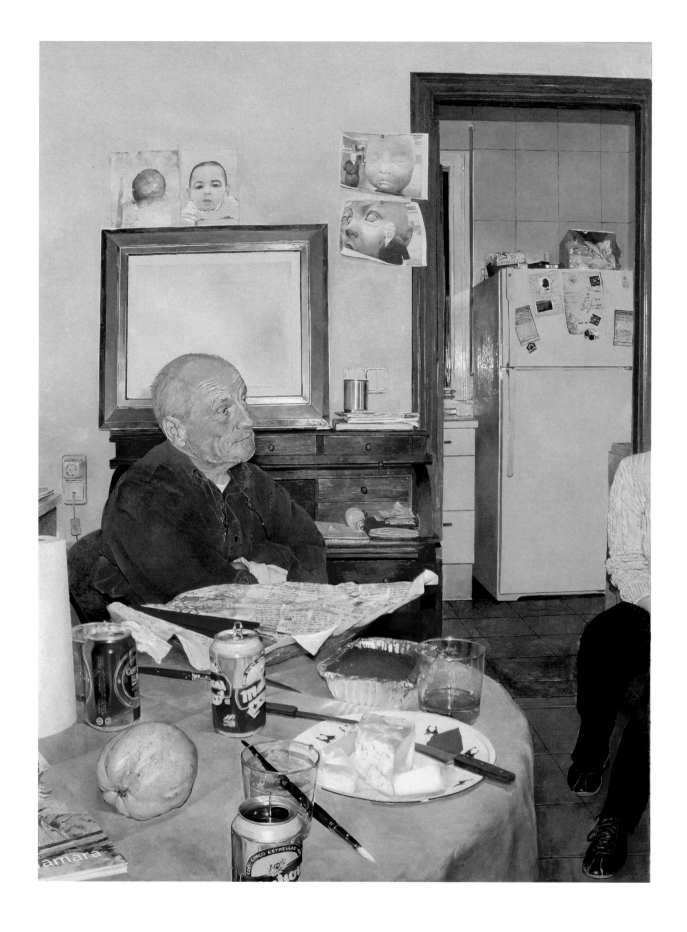

JOSEPH MCNAMARA *MADRID INTERIOR*

2015-2016 oil on panel 40½x30½"

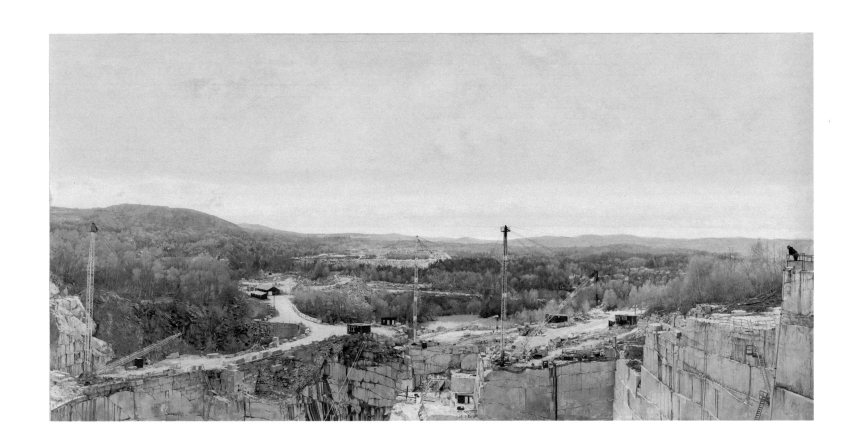

JOSEPH MCNAMARA *VERMONT (E.L. SMITH QUARRY)*

2014-2016 oil on panel 36x72"

JANET MONAFO

born 1940

Of Janet Monafo's work we have included two large pieces, *Open Heart* (1994) and *Silver Cluster (North View)* (2007). Monafo works in pastels and creates large still lifes, often with folded cloth. A good observer will find that some of the same pots and pans, as well as drapes, show up in the paintings of Paul Rahilly. Maybe because of the fact that they lead separate artistic lives in different studios, they are a great couple to know. Paul makes the frames, which are the best, for her work.

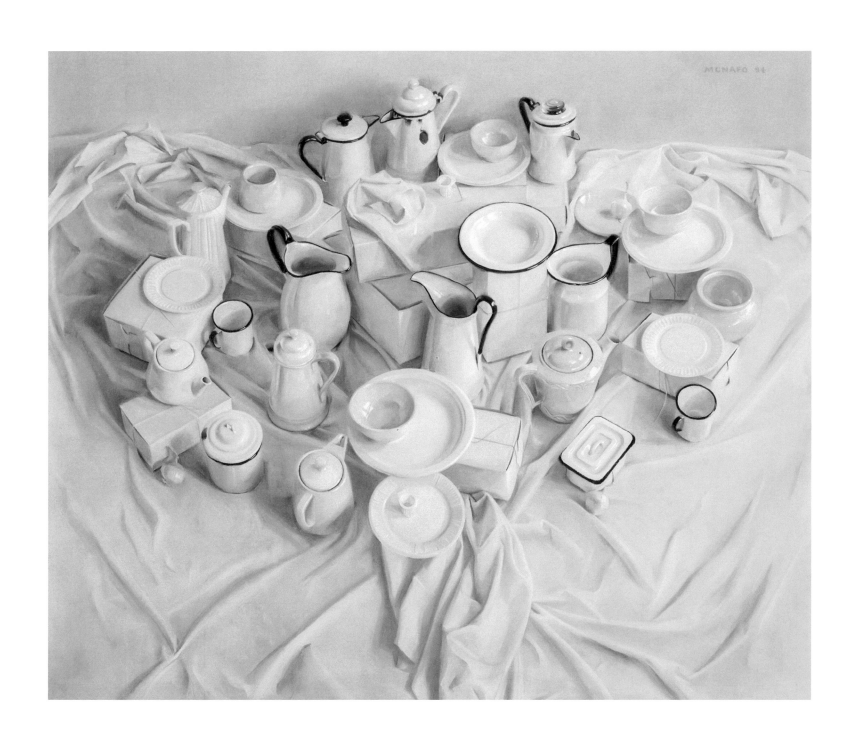

JANET MONAFO *OPEN HEART*

1994 pastel on paper 46x58"

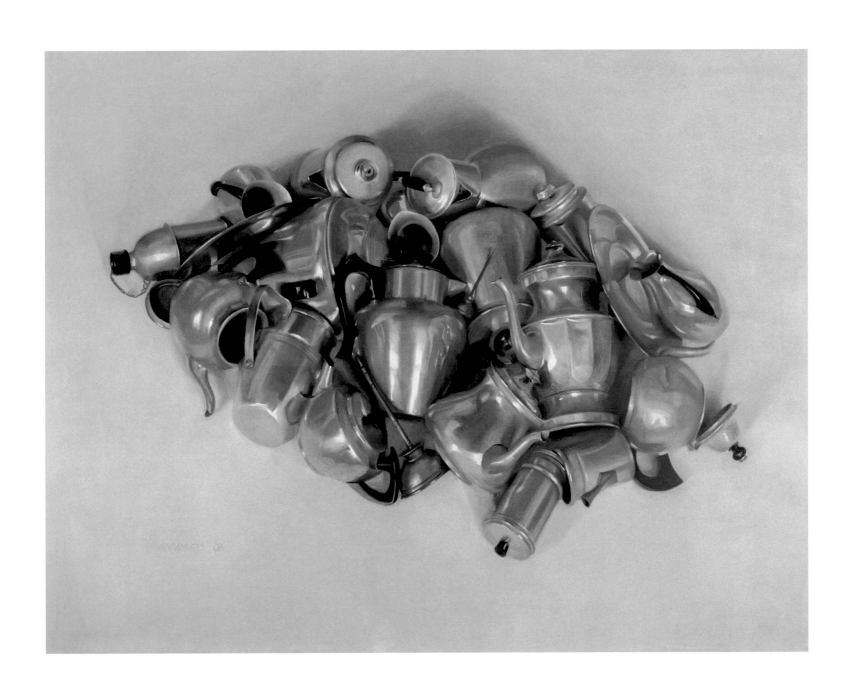

JANET MONAFO *SILVER CLUSTER (NORTH VIEW)*

2007 pastel on paper 38x50"

GEORGE NICK

born 1927

George Nick has played an important role in our life since we first met around 1990. A student of Edwin Dickinson at the Art Students League of New York before he did graduate work at Yale in the early 60s, he faced the challenges of representational painters at that time, when the ability to draw was widely considered to be a handicap for expressing oneself on a canvas. He has a powerful style, which is well recognizable and which is in constant flux as he looks for ways to depict what he sees around him. Nick is in his eighties now, and very dynamic in the way his work evolves. He serves as a role model for me in many ways, one of which is by showing that the way one can hope to survive is to be obsessed by what one is doing. He also serves as a mentor for a number of painters, many of whom were among his students at the Massachusetts College of Art. Among these were Rahilly, Sheehan, Aho, Kehoe, and Stitt, who are in this exhibit. To end this list of attributes, when giving art instruction he is the only person I know who can see some element of merit somewhere in an inept effort.

There is no need to describe what you are seeing in Nick's paintings in this exhibit. Nevertheless, I'd single out the earliest one, *Charlestown Thanksgiving* (1973), which shows how interesting Boston was at that time, in a way one can no longer paint today, and his self-portrait *Katya Moves* (2009), one of the dozens of self-portraits he has produced. Katya is the daughter of George and Assya Nick, and she not only knows George much better than I do, she also is a much better writer than I am. It is rare that artists are written about by people who know them so well, so I am happy Katya Nick gave permission to include the introduction she wrote for her father's most recent exhibit at the Gallery NAGA in Boston in 2015, which is reprinted on the next page.

BUILDING THE PYRAMIDS

The idea of "Art" can be mysterious and unapproachable; however, growing up as the daughter of an artist, I saw art as a completely tangible process. Less mysterious, and much more concrete, it was kind of like watching a Pyramid being built - the glamour of the finished product was a destination somewhere far in the distant future, and far overshadowing it was the grueling minutiae of the discipline and labor comprising it.

Throughout grade school and high school, my routine involved coming home and observing the daily progress of paintings. In addition to my observations on progress, I also bore witness to the latest environmental factors to influence my father's painting. More often than not, my father's commentary was devoted to the weather, and particularly the clouds that might be impacting his light - either currently, or in the anticipated near future. His commentary might also, on occasion, impart feedback from my mother's extraordinarily critical eye. My mother is probably the single person to know my father's process better than himself, as she not only observes his work from day to day, but she has also often experienced most of his painting sites directly. "Better stop now before you ruin it," is a piece of feedback from my mother that my father still loves to share with me, or, even better, "George, do you think that maybe you're using too much red?" - another analysis offered after my mother, over a period of multiple days, continued to find traces of wet red cadmium paint lining the steering wheel and driver's seat of one of our family cars, as well as on doorknobs and faucet handles all around the house.

The minutiae of cohabiting with an artistic process could sometimes distract from, but never dwarf my appreciation for, the structure and rigor that my father brings to his work and his life. Days often start at 5 am in order to get as much "good" (often early morning) light for the one, two, or three paintings on which he could be working at once, and, after about 50 years of teaching, it is still not uncommon for him to dedicate as much time to his students' work as to his own.

The intensity and excitement with which my father approaches everything, including both his painting and teaching, has been as reliable as the North Star. As many of his students will tell you, that excitement is also contagious. If you're lucky enough to have had a chance to study with George Nick, there are many things you may have learned from him, especially if you're interested in color and form; however, among the things I have learned from him are 1) When you're starting out, concern yourself more with the quantity of your work than the quality, and 2) A little guilt goes a long way.

Katya Nick

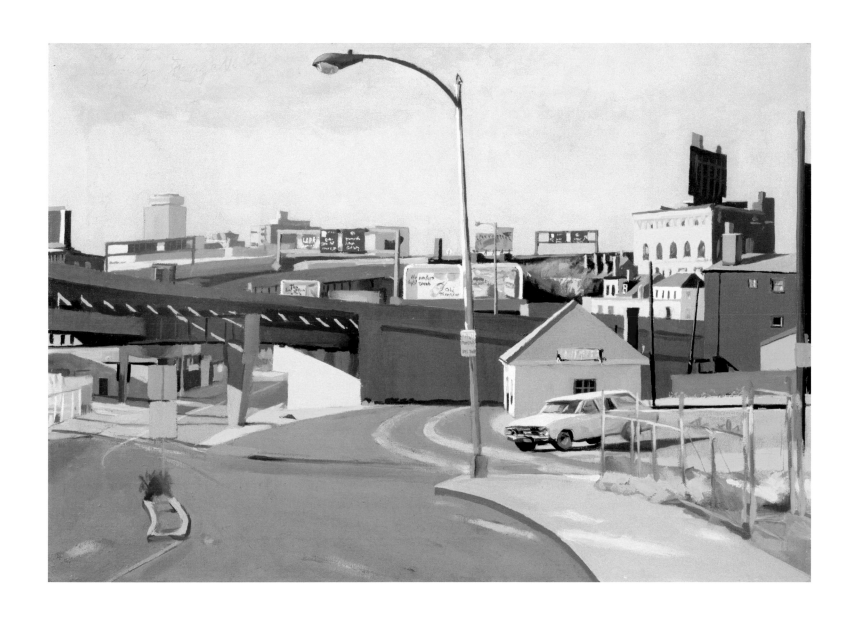

GEORGE NICK *CHARLESTOWN THANKSGIVING*

1973 oil on linen 19x28"

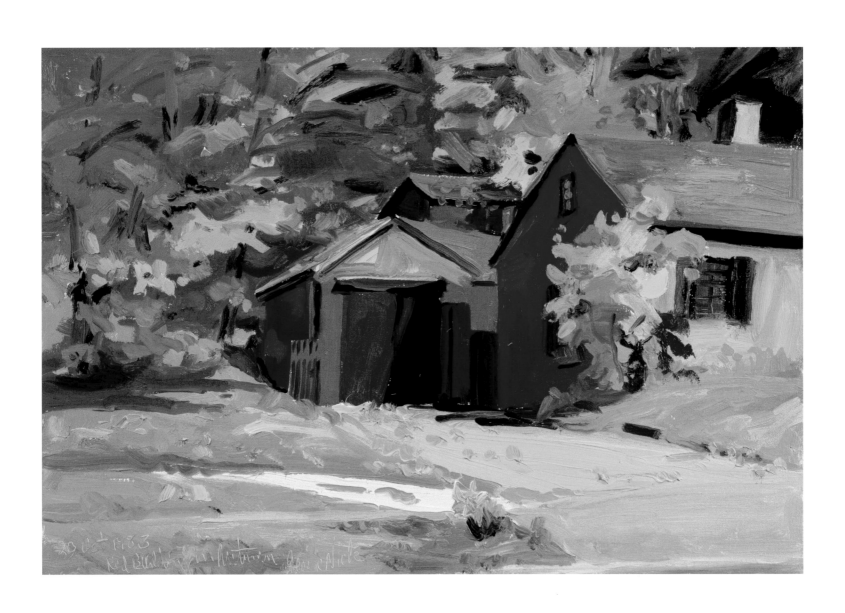

GEORGE NICK *RED BUILDING IN AUTUMN*

1983 oil on linen 20x30"

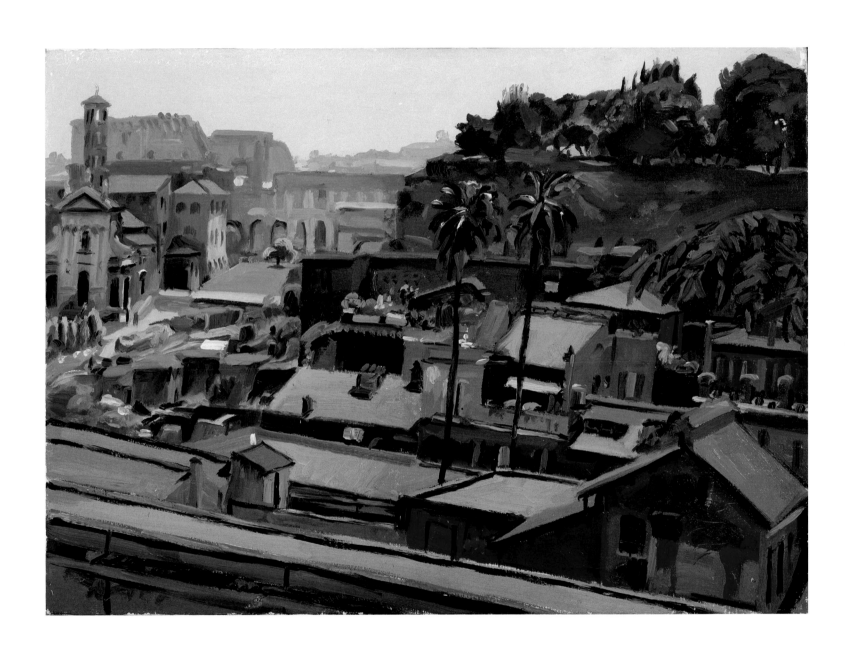

GEORGE NICK *EDGE OF THE FORUM*

1988 oil on linen 20x28"

GEORGE NICK *BUGATTI*

1996 oil on linen 19½x30"

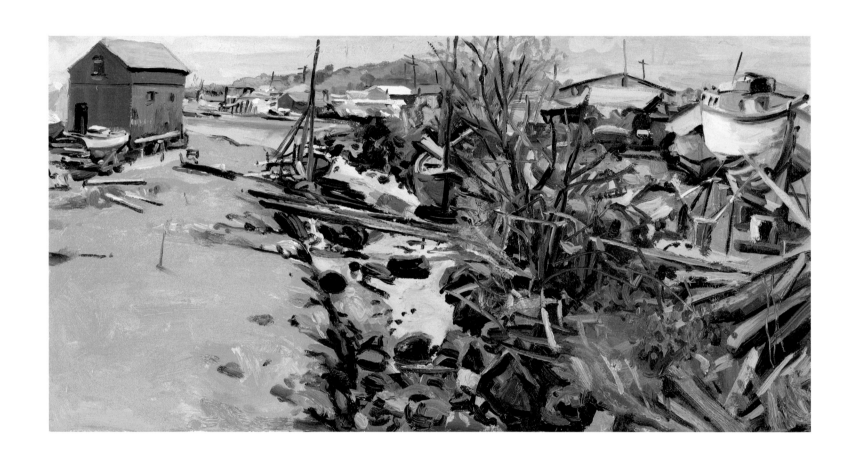

GEORGE NICK *ESSEX HARBOR*

1999 oil on linen 20x40"

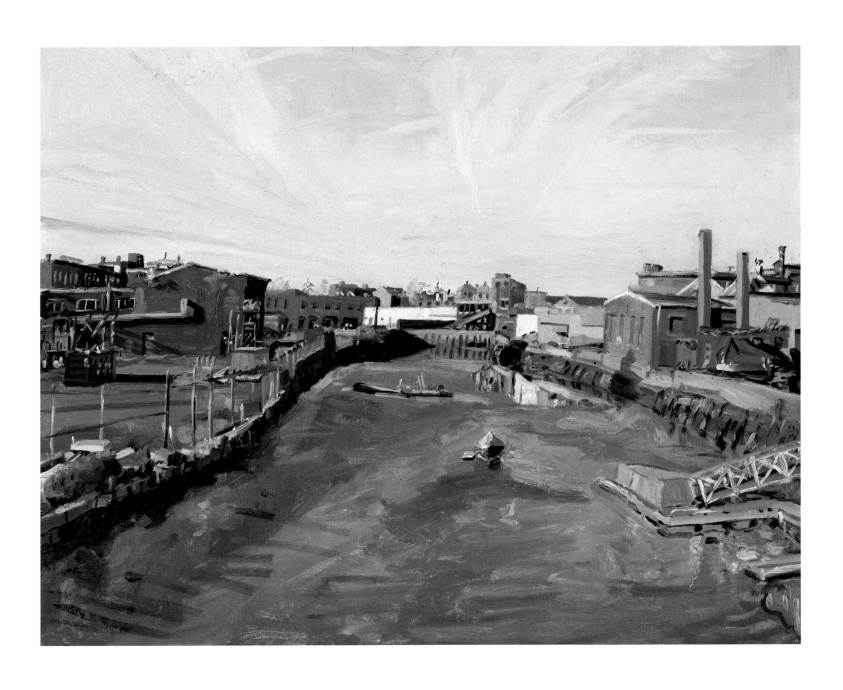

GEORGE NICK *OLD HARBOR, SALEM, MA*

1999 oil on linen 31x41"

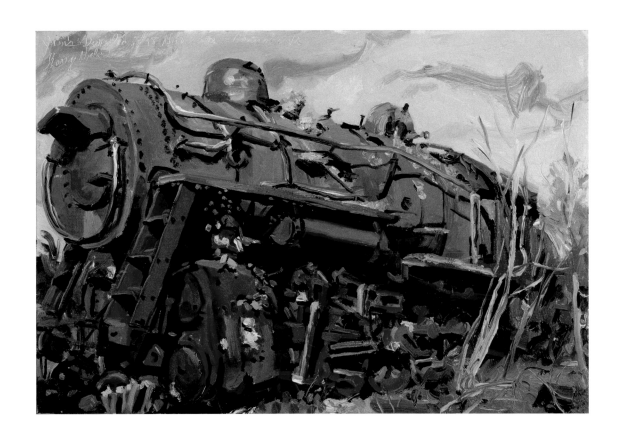

GEORGE NICK *JIM'S DERELICT, ROANOKE, VA*

2000 oil on linen 20x30"

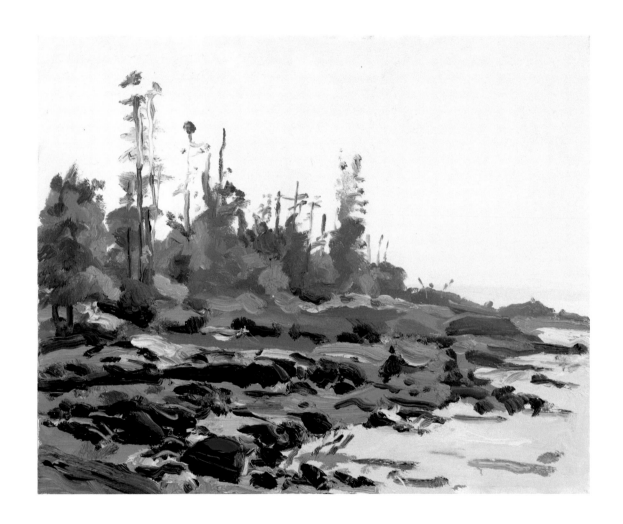

GEORGE NICK *JOE'S VIEW*

2001 oil on linen 16x20"

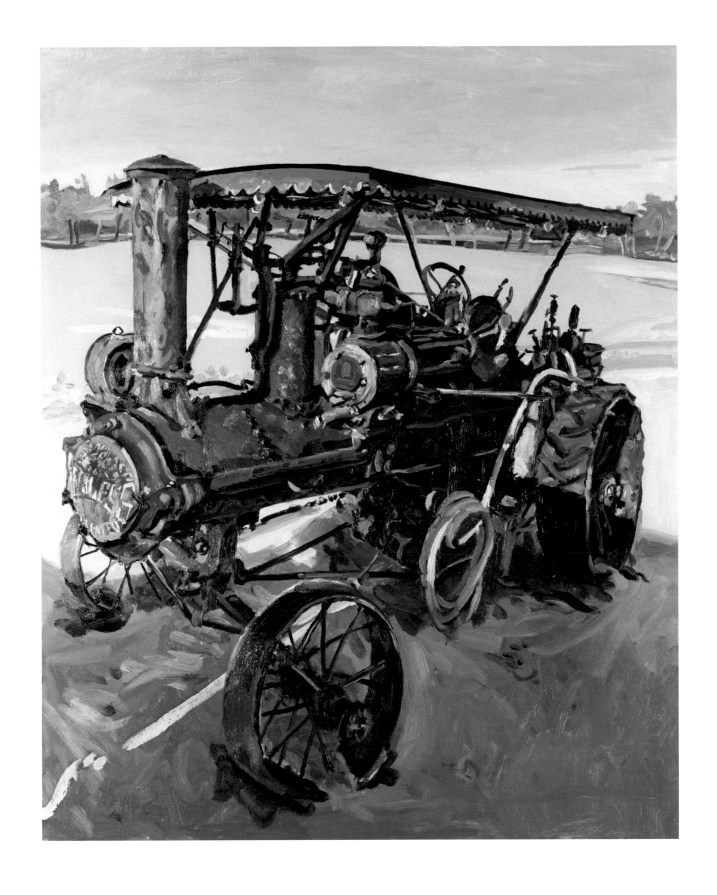

GEORGE NICK *1909 PEERLESS @ COLLINGS, STOWE, MA*

2005 oil on linen 48x40"

GEORGE NICK *JOE'S AMERICAN BAR AND GRILL*

2008 oil on linen 50x40"

GEORGE NICK *FIRMAMENT*

2009 oil on linen 24x50"

GEORGE NICK *KATYA MOVES*

2009 oil on linen 14x10"

GEORGE NICK *CROW'S NOSE*

2011 oil on linen 40x30"

GEORGE NICK *SHORTEST DAY OF THE YEAR*

2011 oil on linen 30x40"

GEORGE NICK *THE CROOKED TIMBER OF HUMANITY*

2011 oil on linen 40x30"

THOMAS PAQUETTE

born 1958

The painting *Quiet Bay* (1996) dates from the time that Paquette lived in Maine. It gives us the feel of the sun breaking out after a rainy day. Some paintings turn out to have unusual attributes, which only become apparent after they arrive at your house. This one is unusual in that it remains quite interesting into the night as daylight disappears. One of the problems in acquiring art from galleries is that good art dealers know how to properly light the paintings, which is hard to replicate at home. With *Quiet Bay* we don't have that issue.

THOMAS PAQUETTE *QUIET BAY*

1996 oil on canvas 26x46"

SCOTT PRIOR

born 1949

Gail and I acquired Scott Prior's painting *Yellow Chair* (1988) in the early 1990s. It was in an exhibit at Alpha Gallery in Boston in 1988 and sold before I got around to seeing it. It had a great impact on me when I first saw it. By pure luck and coincidence I was at the gallery a couple years later, when it was returned by the original collector.

Normally I don't like to be told what I am seeing when I look at a painting, so I should not do the same to others. However, in this instance I cannot resist the urge to describe what I see. *Yellow Chair* shows a scene, likely in Western Massachusetts, around the end of October, when the New England fall still has this warm light, but the early signs of the coming winter cast dark cool shadows in the valley. A wonderful moment, fleeting in nature, in the Indian summer. This painting to me is as American as they come. We moved twice after we got it and always had the hardest time finding a good spot in our house. This painting is quite demanding in where it is hung. The reason, I believe, is that despite the calm it exudes, there is an enormous amount of visual activity in the painting. It tolerates nothing around it which distracts one's eye.

SCOTT PRIOR *YELLOW CHAIR*

1988 oil on linen 48x42"

ALSTON PURVIS

born 1943

Alston Purvis is a professor at Boston University, in charge of the design department. He is quite well known in his field, particularly when it comes to Dutch design of the 20th century. He is a close friend, fluent in Dutch, and leads a hectic life, being somewhat of a workaholic. This latter attribute he is unlikely to have picked up in the Netherlands, where he lived for a number of years. We own a number of his collages, which are a little known part of his life. Their peacefulness and quietness are quite appealing to us and are also somewhat of a surprise, given his lifestyle. These are among the most abstract images on our walls.

ALSTON PURVIS *COLLAGE XX*

1992 mixed media 19½x12½"

117

ALSTON PURVIS *COLLAGE #2*

1993 mixed media 19¾x13¼"

PAUL RAHILLY

born 1933

When I worked at Wellington a visitor occasionally asked if I could show the art on the walls in the public spaces, as in the 70s the reputation of the collection, put together by Stephen Paine, spread around. More often than not visitors would single out Rahilly's *My Pal, Bill Hynes* (1982) as their favorite painting in the collection. It is not difficult to see why, as Rahilly has a very idiosyncratic and forceful, but also very realistic, style of painting, which makes his work quite recognizable. This painting, as I vividly recall, shows Hynes eating a hamburger and reading the paper at a table in a large bare room with some flowers on another table behind him. I think of Rahilly as being interested mostly in making large scenes involving human beings (often nudes), all kinds of draped cloths, bottles, cans, pots, pans, sneakers, and a variety of animals, such as cows and ducks. Between these works he makes smaller still lifes. I remember art reviews of Rahilly's work with various opinions and interpretations about what the images mean. These reviews all somewhere would mention how well he paints, particularly difficult subjects such as aluminum garbage cans and white paper bags. Maybe all these accoutrements are to show off his skills, which is fine with me. In my own efforts to make paintings I put as little in as possible, in order to minimize the chance of awkward mistakes.

This exhibit has a number of his larger paintings and smaller still lifes. The painting *Figures with Rolled Paper* (1982) hangs in our dining room and often elicits questions from guests as to what the ladies are thinking, how old they are, which one looks healthier, and do we know who they are. When you ask Rahilly about how to answer these questions, he will vaguely talk about the models, who are often composites, where he got the lobster, how he got the newspaper rolls, and most importantly the various compositional opportunities he found and challenges he faced while making the painting.

We acquired *Bill Hynes with Violin* (1994) recently from Rahilly, who purchased it back in an auction of the estate of a collector of his work. Hynes, who has passed away, was a good friend of Rahilly, who told me that Hynes was always expressing the hope that the painting one day would be in a museum, a wish now fulfilled. To me this painting, like the one mentioned earlier, is proof of the theory that the best portraits are those of good friends.

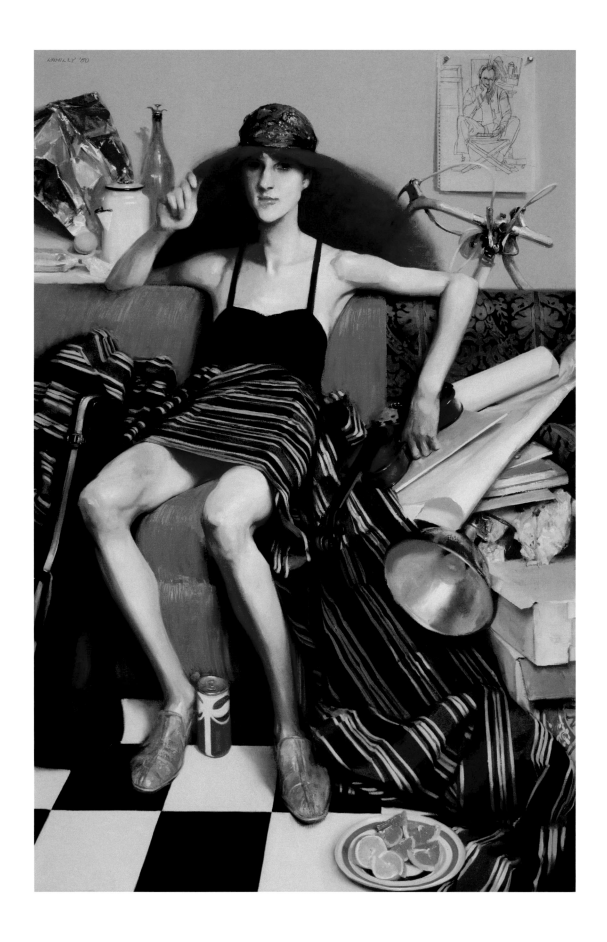

PAUL RAHILLY *THE VIOLINIST*

1980 oil on canvas 60x40"

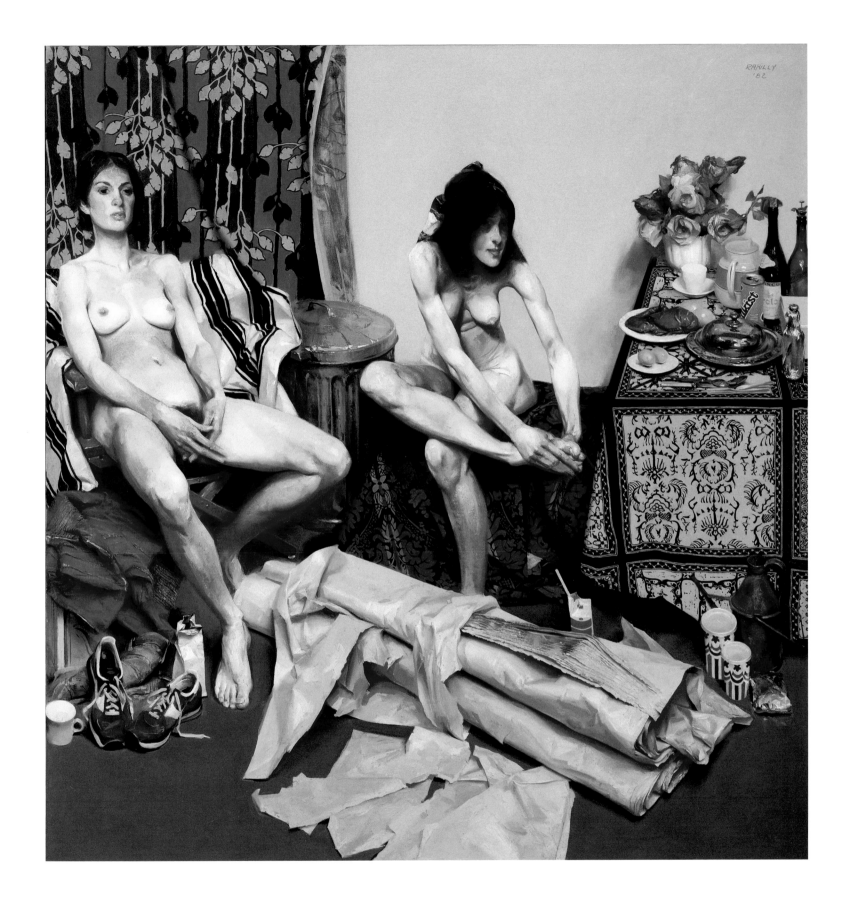

PAUL RAHILLY *FIGURES WITH ROLLED PAPER*

1982 oil on canvas 72x70"

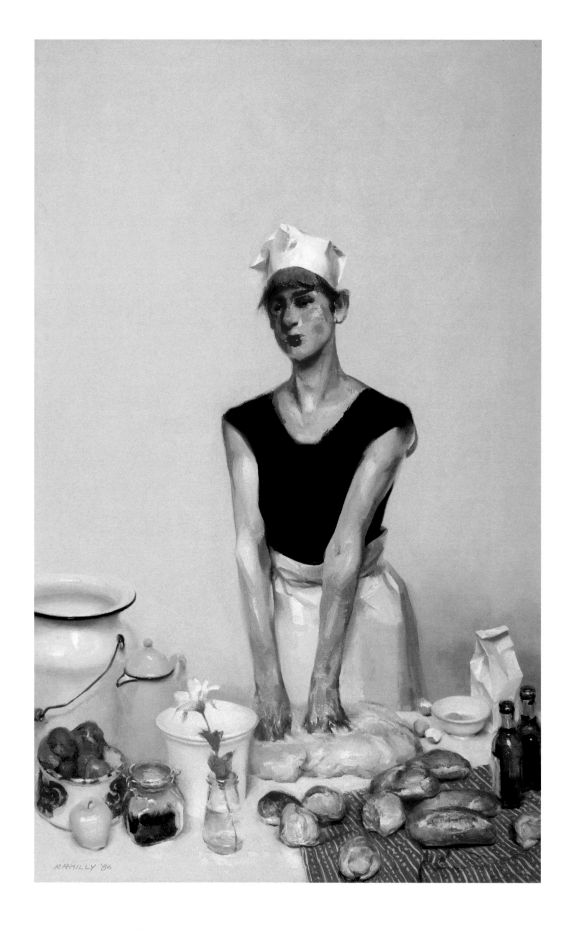

PAUL RAHILLY *BAKER*

1986 oil on canvas 48x30"

PAUL RAHILLY *STILL LIFE WITH GARLIC AND PEAR*

1991 oil on canvas 12x16"

PAUL RAHILLY *STILL LIFE, ROSE & CABBAGE*

1992 oil on canvas 18x24"

PAUL RAHILLY *STILL LIFE WITH BREAD AND WATER*

1993 oil on canvas 18x22"

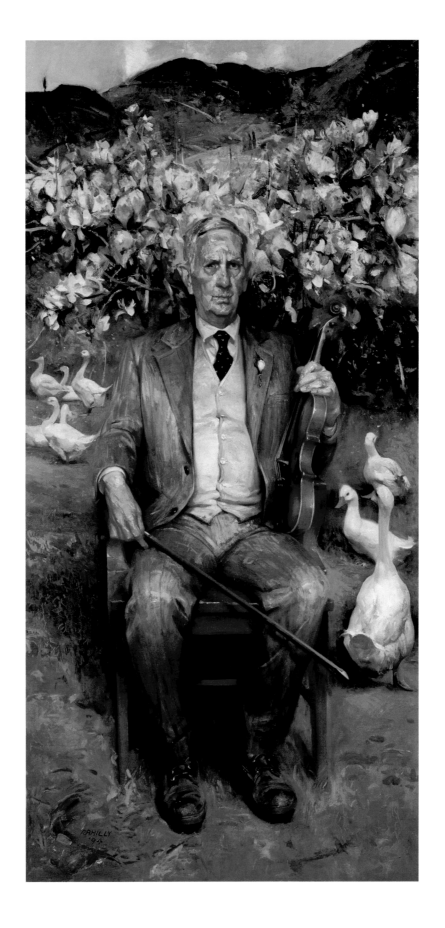

PAUL RAHILLY *BILL HYNES WITH VIOLIN*

1994 oil on canvas 70x34"

PAUL RAHILLY *FIGURE ON YELLOW*

1994 oil on canvas 20x30"

PAUL RAHILLY *STILL LIFE WITH ROSES AND STICKY BUNS*

1996 oil on canvas 24x18"

PAUL RAHILLY *STILL LIFE: TEAPOT AND GRAPES*

2002 oil on canvas 18x24"

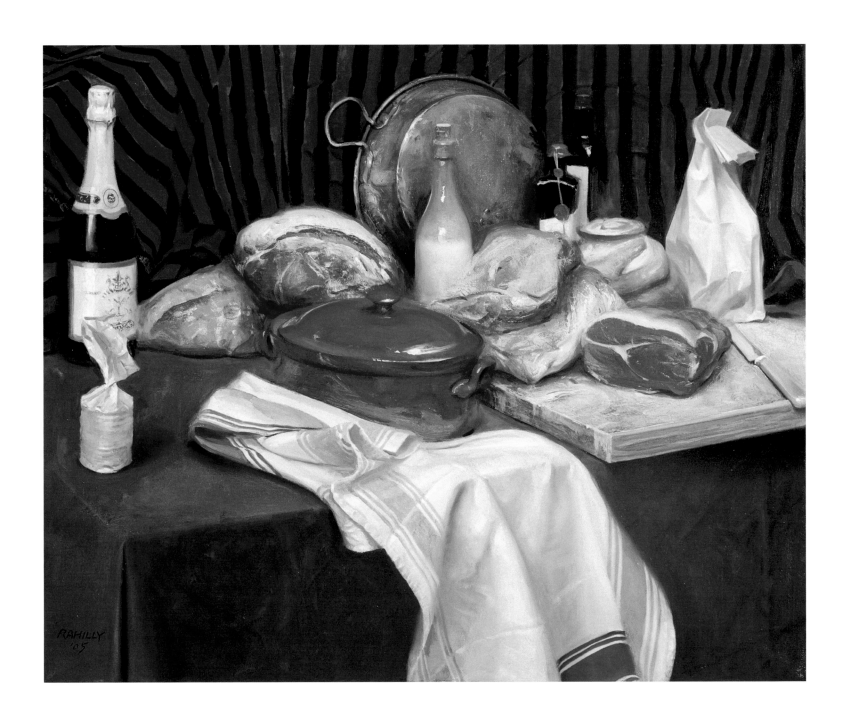

PAUL RAHILLY *BRUNCH*

2005 oil on canvas 24x30"

RICHARD RAISELIS

born 1951

 Gail and I own some pieces by Raiselis, a painter of the New England scene. One is the view of Boston's Custom House Tower, more or less from the vantage point from my office at Wellington Management in the late 1990s. Raiselis has spent a number of years in the Boston financial district working on interesting visual situations involving often not very great-looking architecture. The Custom House Tower of course does not present this visual challenge, but one is also allowed to collect art with a view to remember.

 I allude elsewhere to the difficulty of painting clouds, and Raiselis knows how to do it. These are little scenes of clouds that appeared in front of his studio at Boston University when he had his brush ready.

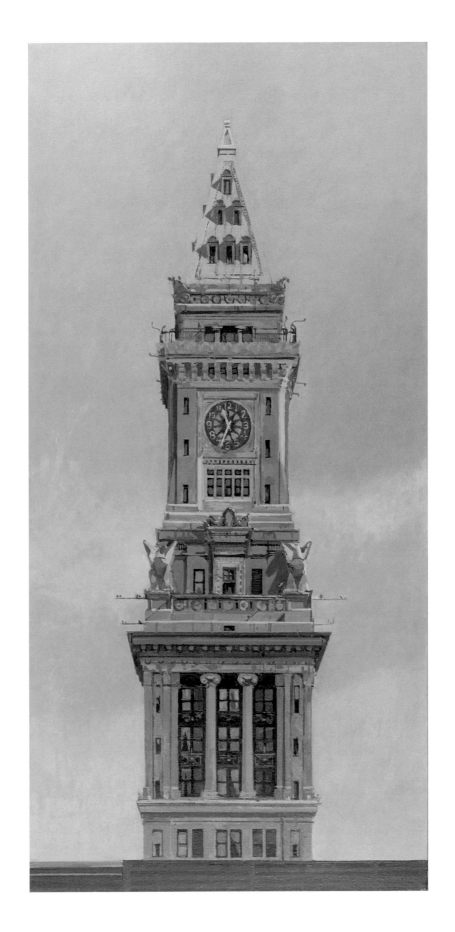

RICHARD RAISELIS *EQUINOX*

2004 oil on linen 36x18"

RICHARD RAISELIS *SUNDAE CLOUD*

2009 oil on panel 6x6"

RICHARD RAISELIS *#26*

2009 oil on panel 6x6"

RICHARD RAISELIS *B.D.*

2010 oil on panel 6x6"

RICHARD RAISELIS *ICARUS*

2011 oil on panel 6x6"

HAROLD REDDICLIFFE

born 1947

 Gail and I first met Reddicliffe in 2003, when Julia became an undergraduate at Boston University. For a freshmen parents' afternoon he gave a talk about the school, which I expected would focus on how the students would all enjoy the environment and become great artists. Instead we got a one-hour lecture about how students would be subjected to a two-year schedule, during which they would learn how to draw, after which more freedom would enter their lives. It was a fascinating talk, and I wish I had recorded it. Reddicliffe paints highly thought-out still lifes in his studio and is extremely sensitive to the light that falls on his subjects. I have lunch with Reddicliffe and Nick once in a while, and it is always a pleasure to see that they are good friends, even though neither of them is making any progress in changing the way the other paints.

HAROLD REDDICLIFFE *CIGARETTE LIGHTER ON PLANT STAND*

2006 oil on canvas 15x12"

HAROLD REDDICLIFFE *CIGARETTE LIGHTER WITH 44 SQUARES*

2006 oil on canvas 12x10"

RICHARD SHEEHAN

1953-2006

Sheehan, as mentioned earlier, was the first Boston painter we collected. I got some paintings in the early 70s when he showed in Boston. He moved to Rhode Island around 1980, and I lost touch with him, but we kept enjoying the work we had. He was a student of George Nick and acquired a lot of his habits, such as signing his work in wet paint. Sheehan was strongly influenced by the shapes and light contrasts generated by highway overpasses and had a fauvist manner, most vividly shown here in one of his last paintings, *untitled* (2006). Looking at *Freeport Street Exit* (1983) I realize that a number of the painters in this exhibit, like Nick and McNamara, are fascinated by subject matter, such as industrial detritus and puddles, which most people avoid looking at. This probably says something about the mindset of the collector.

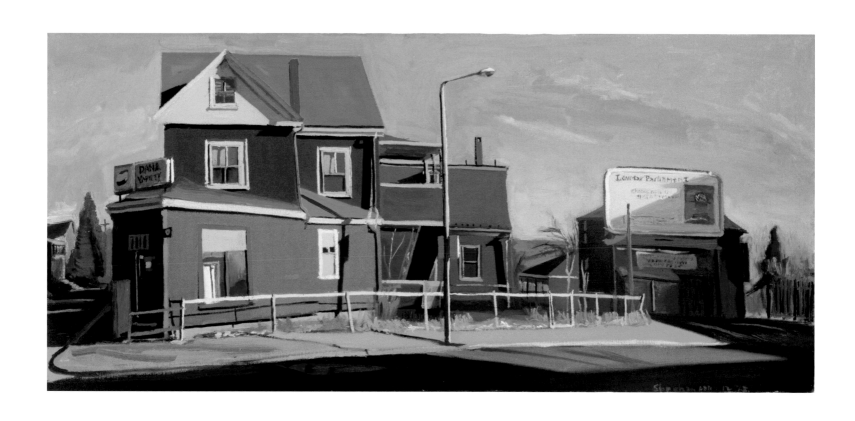

RICHARD SHEEHAN *DANA VARIETY*

1978 oil on canvas 30x66"

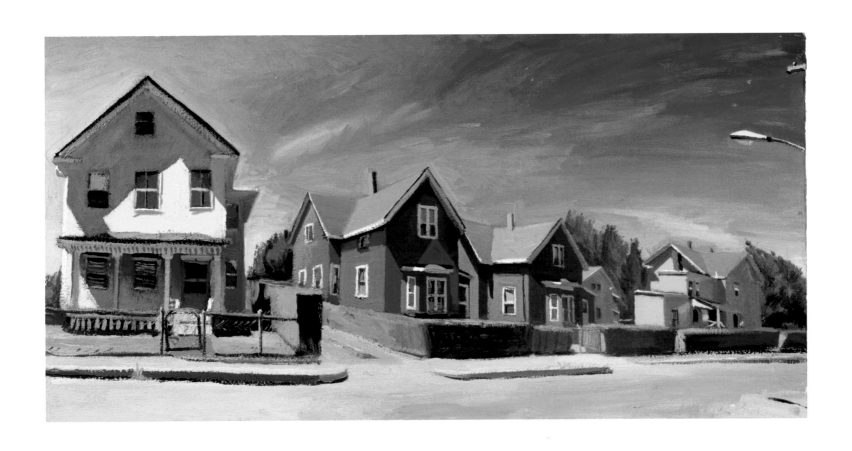

RICHARD SHEEHAN *SUMMER STREET, HYDE PARK*

1978 oil on canvas 22x44"

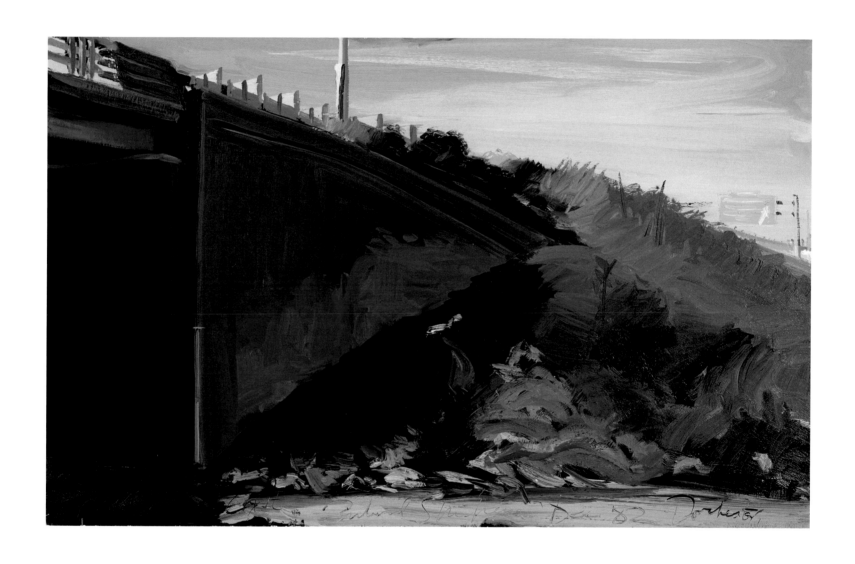

RICHARD SHEEHAN *FREEPORT STREET EXIT*

1983 oil on canvas 32x52"

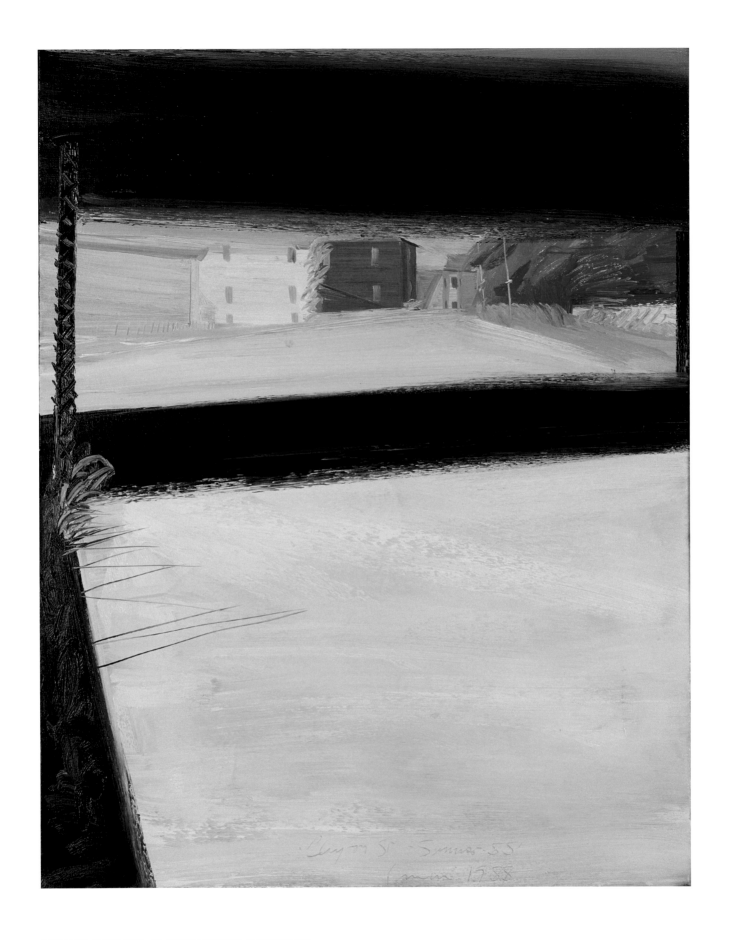

RICHARD SHEEHAN *CLAYTON STREET, SUMMER '88*

1988 oil on canvas 48x39"

RICHARD SHEEHAN *NEPONSET DRIVE-IN BRIDGE, EARLY FALL, USA*

1988 oil on canvas 16x10"

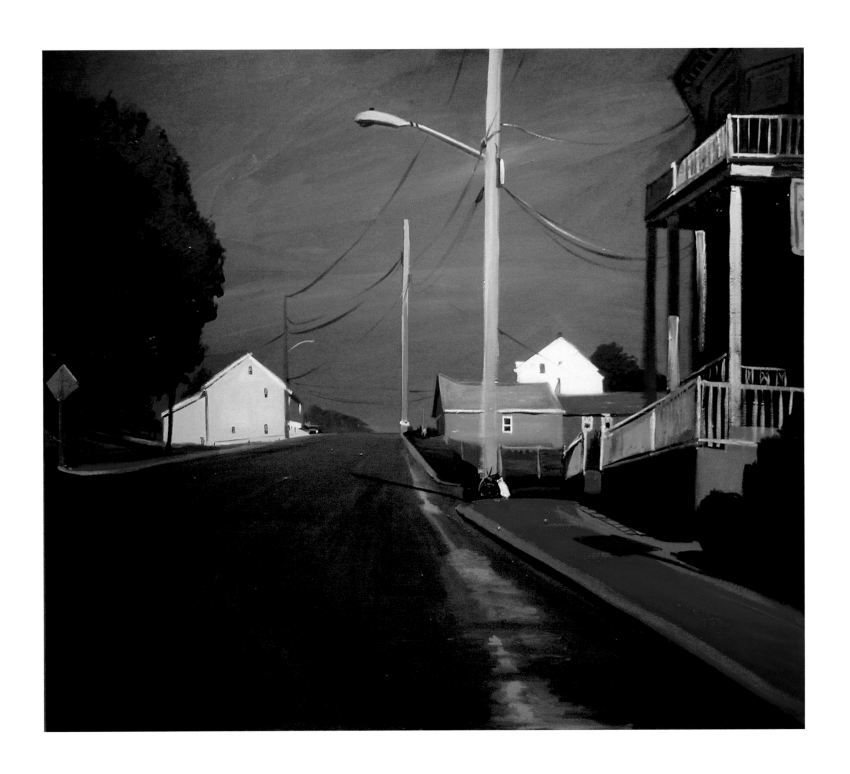

RICHARD SHEEHAN *UNTITLED*

2006 oil on canvas 44½x51½"

ED STITT

born 1957

Ed Stitt works in Boston, painting mostly city scenes, which is how I discovered him. For years I had in my Wellington office a wonderful little painting by him of a Boston brownstone. Stitt also had worked in portraiture, and when my older son Roland turned 21 in 1992, I asked Ed to paint Roland's portrait. Stitt took a classical approach, made sketches, and had Roland sit for something like 36 hours in his Fenway Studio. The painting was a great success, which we originally took for granted, but we later realized that making a painting that captures both the looks and the personality of the sitter in an interesting way is hard. Under the constraints of representational painting it is very difficult to explain poorly drawn and painted features as being the result of an artist's liberty to see it in an unusual way. We also have a painting by Stitt of our son George and a number of his street and landscape paintings.

I want to single out a copy of a painting by Velázquez that Stitt made in 1993. I have mentioned earlier that artists are the best students of art history, and this painting shows it. Stitt copied the Velázquez painting *Luis de Góngora y Argote* (1622) in the Museum of Fine Arts (MFA) in Boston. This painting is of historic interest because it was done when Velázquez was barely 23, and unknown, while de Góngora was about 61, a famous poet, embittered at his loss of stature at the Spanish court. Stitt studied the palette of Velázquez closely and, in the manner of the classical painters who did not have the luxury of paint tubes, used only four pigments: flake white, ivory black, yellow ochre and Venetian red.

Over the years, for obvious reasons, many copies of this painting have been made. Two copies were likely made by Velázquez himself and are in Spanish museums. It does not take an expert eye to see that the Boston one is the original and the most interesting of the three. It brings out de Góngora's personality; the Spanish copies only show what he looked like.

The text in the MFA describes it as one of the most incisive psychological studies by one of history's great portraitists. I totally agree, but wonder why then is it exhibited in such an obscure location in the museum? Stitt did a great job, and his copy is much more interesting than the two copies by Velázquez himself in Spain. It is shown here with a dark frame, which brings out the painting much better than the distractive golden frame at the MFA, where the painting also suffers from being behind glass. My conclusion from all this is that one can get great enjoyment out of a good copy, arguably at times more so than going to a museum to see the original with its impeccable provenance.

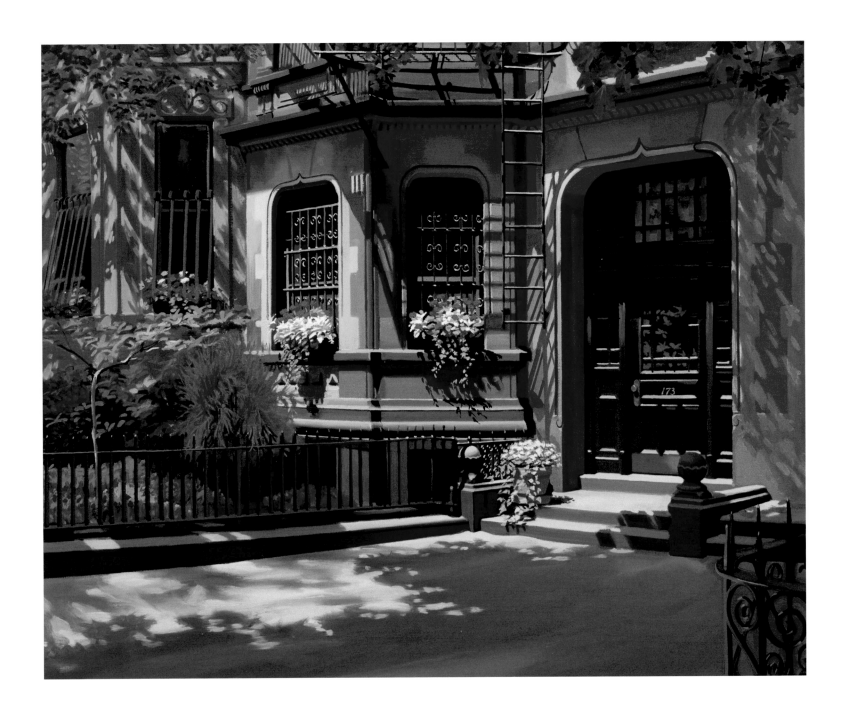

ED STITT *173 MARLBOROUGH STREET*

1993 oil on linen 32x40"

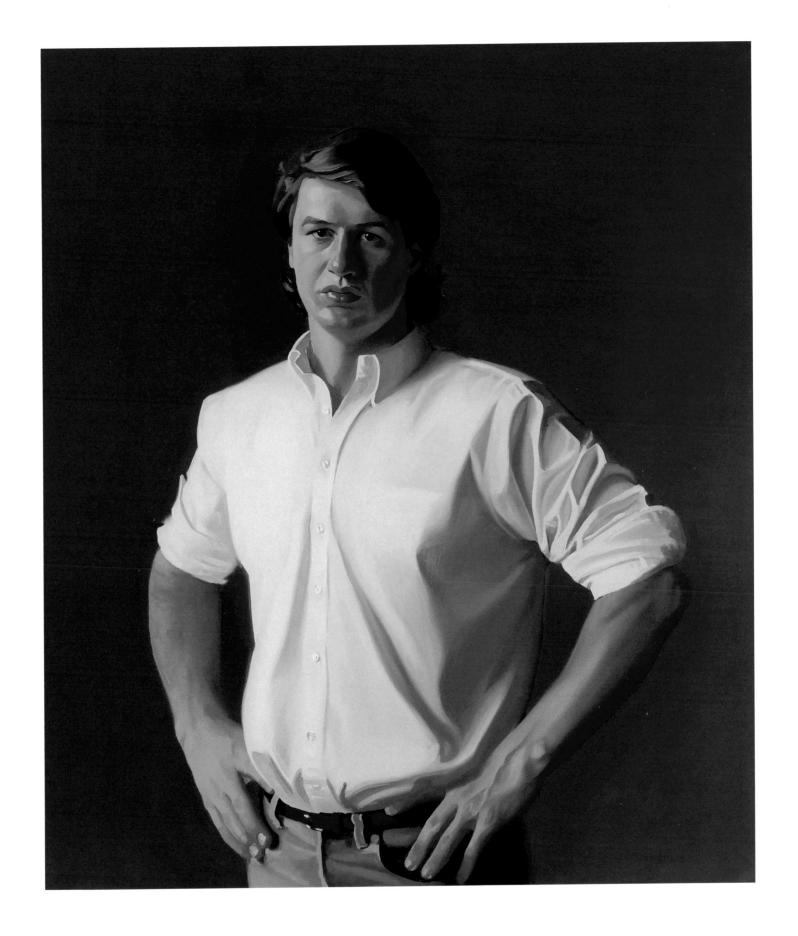

ED STITT *ROLAND VON METZSCH*

1993 oil on linen 38x34"

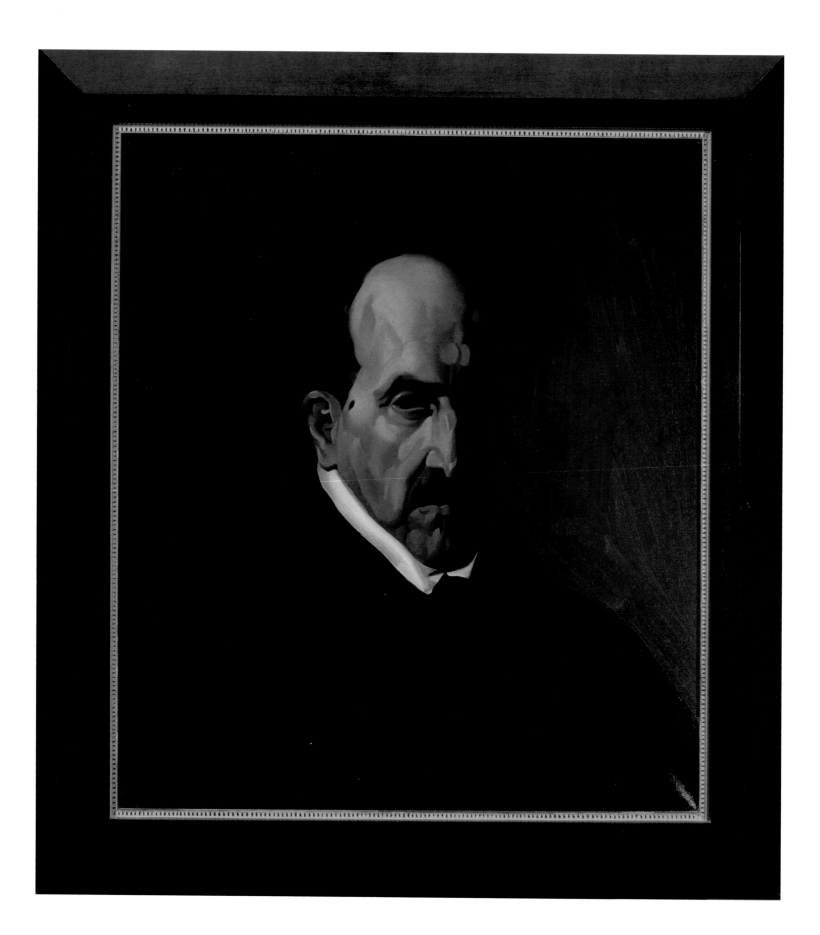

ED STITT *LUIS DE GONGORA*

1994 oil on linen 20x18"

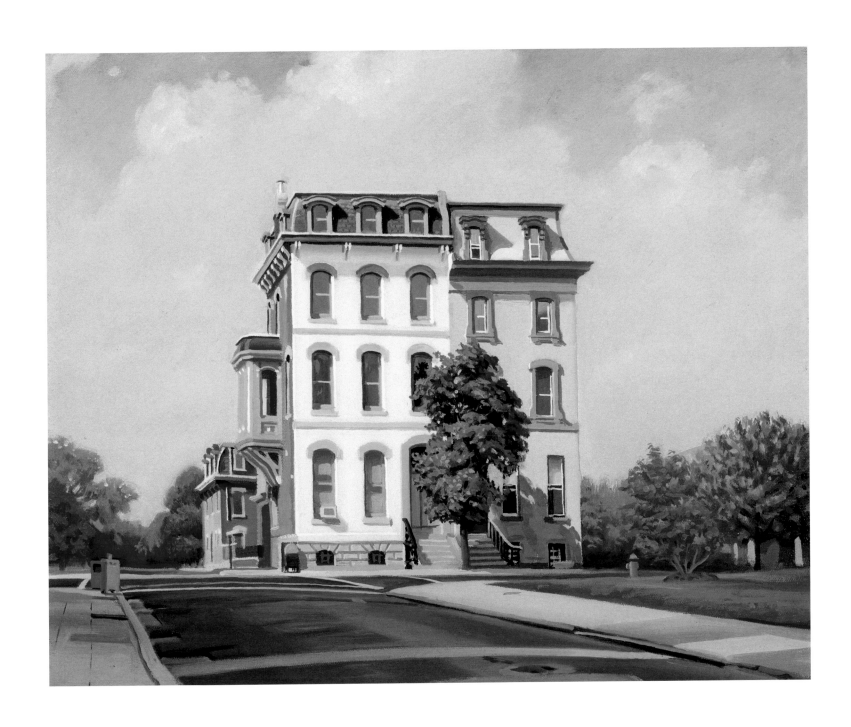

ED STITT *1733 SPRING GARDEN*

1996 oil on linen 16x20"

ED STITT *GEORGE VON METZSCH*

2008 oil on linen 38x34"

SARAH SUPPLEE

1941-1997

We acquired several paintings of Supplee in the late 1990s, after she passed away. She painted great landscapes, often in New York, using a red undercoat on the canvas, which gives her work great warmth.

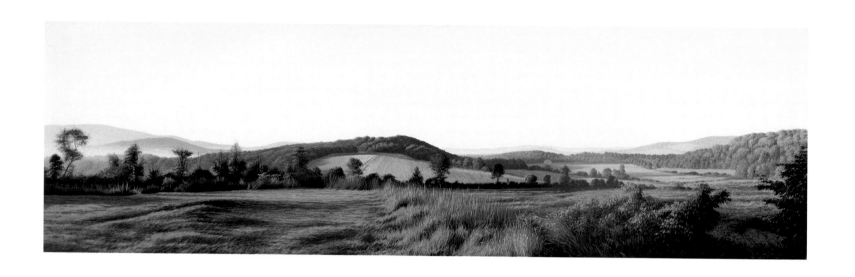

detail

SARAH SUPPLEE *ABOVE COPAKE*

1996 oil on canvas 27x92"

SUZANNE VINCENT

born 1962

I first saw Vincent's work at Wellington, where there were two portraits by her, collected by Steve Paine. Gail and I commissioned this portrait in the mid-1990s. The work is in egg tempera. Making a portrait is hard, but commissioning a dual portrait is very risky. This one was successful with both sitters. Vincent obviously has great drawing skills and spent a lot of time contemplating how Julia and George really looked. Vincent also put a lot of work into all the furniture and the portrait of our corgi, Lilly.

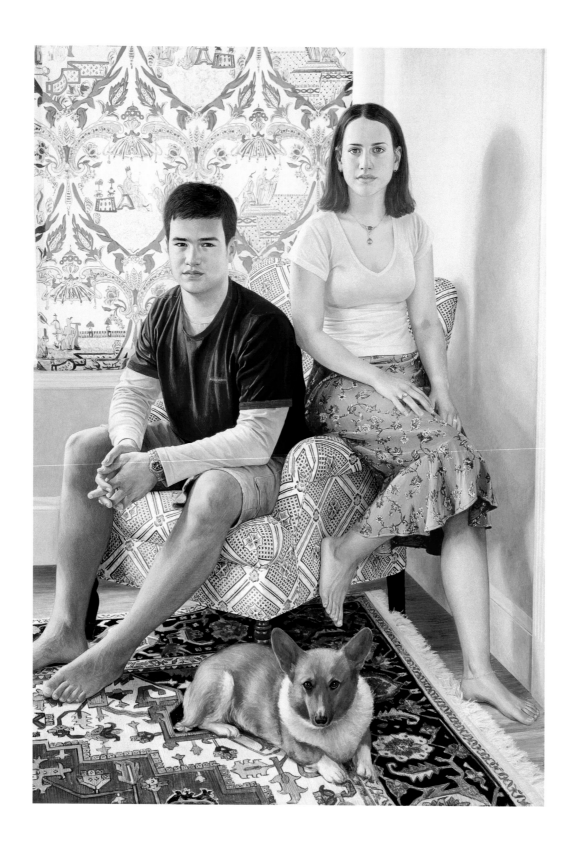

SUZANNE VINCENT *JULIA AND GEORGE*

2002 egg tempera on panel 54x38"

JULIA VON METZSCH RAMOS

born 1985

We have included some of the work of our daughter Julia in this exhibit. We like her work and have a collection of her paintings, some of which are in our living room, which serves as a housekeeping seal of approval. It is very interesting to have a close family member who is an active artist. The biggest advantage is that there is an inexhaustible amount of things related to art to talk about. The biggest challenge is to leave her alone in her work. Painters in general get subjected to way too much opinion and advice from their collectors, and if the collector is your father it is much worse.

JULIA VON METZSCH RAMOS *BIRD ON ROCK*

2010 oil on paper 20x24"

JULIA VON METZSCH RAMOS *ATLANTIC OCEAN*

2011 oil on panel 30x40"

JULIA VON METZSCH RAMOS *COOLIDGE POINT*

2011 oil on panel 20x30"

JULIA VON METZSCH RAMOS *BUTTERFLY AND SHARK*

2012 oil, sawdust, and varnish on panel 60x48"

JULIA VON METZSCH RAMOS *RUSTREL*

2015 oil on panel 15x22"

JULIA VON METZSCH RAMOS *SNOW DRIFTS AND KETTLE ISLAND*

2016 oil on panel 24x36"

JOHN WALKER

born 1939

We own two of John Walker's series of paintings on bingo cards. Walker is well known for his work as an abstract painter and is somewhat out of our representational frame of reference. The paintings in this exhibit bring up strong suggestions of landscape and are great to look at. We met Walker when he was running the graduate painting program at Boston University. Under his leadership this program at BU flourished. In academia many fields of endeavor can attract good students when the teaching is bad as long as the research is good. Art departments need to be run by people who both paint well and are great mentors.

JOHN WALKER *HARRINGTON ROAD SERIES #16*

2010 oil on bingo card 7x5½"

JOHN WALKER *HARRINGTON ROAD SERIES #28*

2010 oil on bingo card 7x5½"

JEFF WEAVER

born 1953

Weaver lives in Gloucester, Massachusetts, in the tradition of such painters as Gruppe and Hibbard. He draws really well and has a great feel for light. I got attracted to this painting by two things. First, it has an interesting composition with movement in two directions. Second, painting the ocean is hard, especially the Atlantic swell, which has dramatic action, but often not a lot of breaking waves. Nick introduced me to Weaver, after he met him while working in Gloucester himself. One is not supposed to recommend studio visits in catalogs, but Weaver's gallery/studio on Rogers Street is a great place to visit.

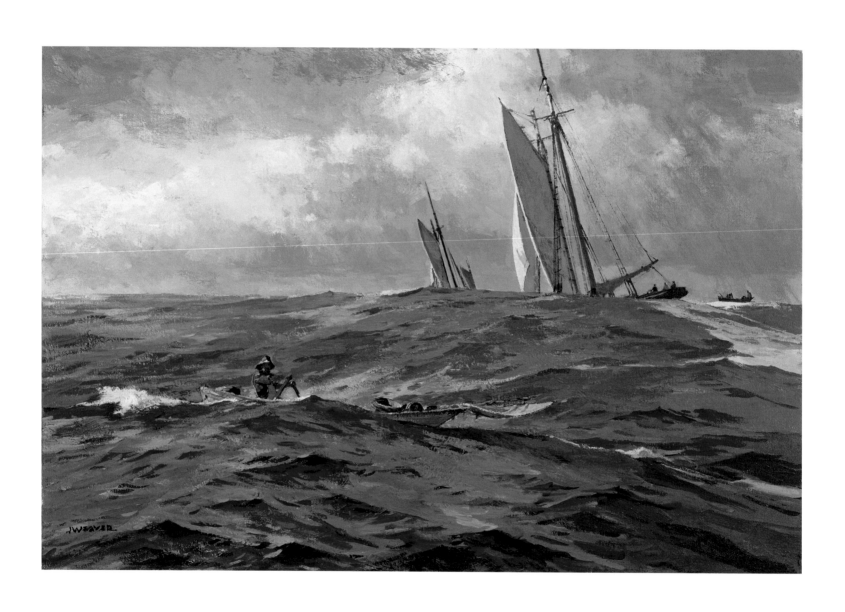

JEFF WEAVER *ON THE FISHING GROUNDS*

2012 oil on canvas 24x36"

LUCETTE WHITE

1932-2014

White lived in Gloucester and was a painter of realistic landscapes and also more abstract interpretations of nature. She was a pupil of Bernard Chaet and played an important role in our daughter Julia's development, introducing her to the Mercury Gallery, then in Boston. I think of her as a Southern belle from Arkansas, whose work was shown at the White House during the Clinton presidency. This did not prevent her from painting our house in Manchester, the work shown here, during an awful northeaster.

LUCETTE WHITE *CROW ISLAND*

2010 gouache on paper 18x21"

ERNST VON METZSCH

born 1939

The last painting in this catalog is a copy I made of the painting *Route 6, Eastham* (1941), which Hopper painted on Cape Cod, just before the attack on Pearl Harbor. Virtually all great painters have made copies of works of earlier artists, for the simple reason that it is a great way to learn how to make paintings. The same is true for less recognized painters, like me. Painting increases one's realization that making good art is admirable and that it is quite an achievement to make a good composition and to use an interesting palette. Getting some help by making copies is a good idea... It is also a great hobby, as one's mind gets totally absorbed by overcoming the setbacks and enjoying success when it comes, at least in one's own perception. Several great art writers, like Kenneth Clark and Robert Hughes, at one point pursued making visual work, which in my view makes their writing much more interesting.

For reasons explained below, my painting is called *Route 6, Eastham, 10 minutes later*. I painted this in 1996, using a copy of the original by Hopper as my model. Hopper's way of applying the paint is straightforward, which makes it less difficult to copy. Copying the thick impasto in a painting by Aho or Nick would be much more difficult. There are books out on the current appearance of the scenes Hopper painted. This house has been overlooked in the literature but was still there about ten years ago, unchanged in appearance, except that it is surrounded by trees and Route 6 no longer is the rural road it was when Hopper painted it. Hopper, who had a hard time finding suitable subject matter, was happy when he found and painted it. He then spent some time driving around looking for a suitable sky.

In 2007 the MFA in Boston had a retrospective of Hopper, in which his painting of this scene was exhibited. I kindly offered to Carol Troyen, who curated the exhibit, that she might want to include my work in the section "School of Hopper," if there was going to be one. She politely declined my suggestion, but when I showed her an image of my painting she was quite struck. "You have totally transformed his work," she said. And then I realized I had. In order to make it just a little more than a copy, I put an image of a 1940s policeman on a Harley-Davidson on the road, trying to emphasize the effect of the long shadows, while looking for a spot where he would not ruin the composition. What Carol Troyen saw was absolutely right. Without the policeman your eye gets drawn from left to right by all the elements of the composition, clouds, telephone poles, and the road. The policeman going from right to left pushes your eye back into the picture. One can see that by holding one's thumb (please don't touch!) over the policeman. So this is not a copy after all!

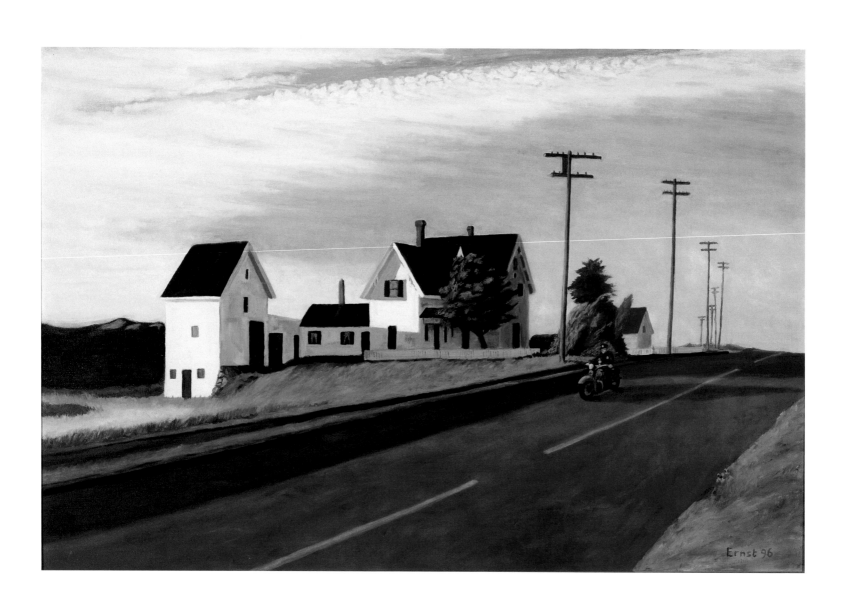

ERNST VON METZSCH *RTE 6 EASTHAM, 10 MINUTES LATER*

1996 oil on canvas 24x36"